Dan Namingha

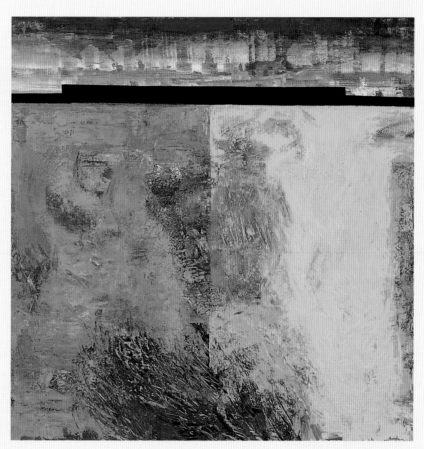

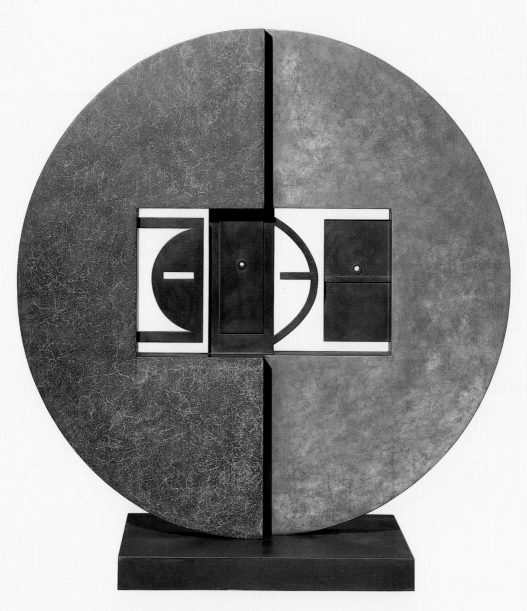

HARRY N. ABRAMS, INC., PUBLISHERS

The Art of Dan Namingha

BY THOMAS HOVING

Editor: Robert Morton
Designer: Robert McKee

Library of Congress Catalog Card Number: 99–69675

ISBN 0–8109–4050–7

Published in 2000 by Harry N. Abrams, Incorporated, New York

Printed and bound in Japan

Harry N. Abrams, Inc.
100 Fifth Avenue
New York, N.Y. 10011
www.abramsbooks.com

HOPI LANDSCAPE (page 1). 1998. Acrylic on canvas, 72 x 72". Private collection.

DUALITIES (page 3). 1998. Bronze, edition of 6, 51.5 x 48.5 x 7.75".

HOPI POTTERY MOTIF (page 6). 1980–81. Acrylic on canvas, 60 x 48". Collection the artist.

The rust, terra-cotta, and black semi-abstract shapes, which are keenly and decisively painted, represent traditional pottery designs—perhaps resembling what Namingha's great-great-grandmother, Nampeyo, might have created. As he says, "They are arranged to suggest what you might find if you were suddenly to walk onto an archaeological site and discover shards of ancient Hopi pottery decorated with intricate designs such as the whirl, which represents a bird. I wanted the dark area on the top to be both a formal element for contrast and to add a touch of mystery, suggesting questions such as how far does this site go back in time and who formed and designed the pottery? I painted the flat and overlapping pastels in a variety of textures—you can see under colors coming through—to suggest layers and layers of time."

SIKAYTKI SPRING (opposite page). 1977. Acrylic collage on paper, 36 x 29". Private collection.

Sikaytki is an archeological site four miles east of the village of Walpi, below First Mesa and near Polacca, where Namingha grew up. "As a kid I hiked or hunted for small game there. When I took shelter from the summer heat or became thirsty I'd drink from a natural spring near Sikaytki. Surrounding this spring are some small sand dunes and a grove of cottonwood trees. This painting is not a literal representation of the place, but an abstract image summing up my feelings about the area."

For this work, the artist glued newsprint to watercolor paper and applied acrylic washes on top to achieve the layered density of the scene.

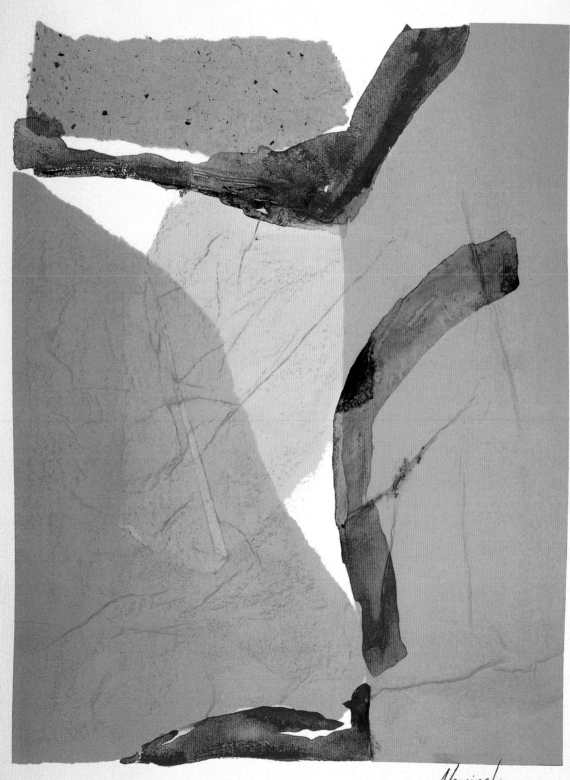

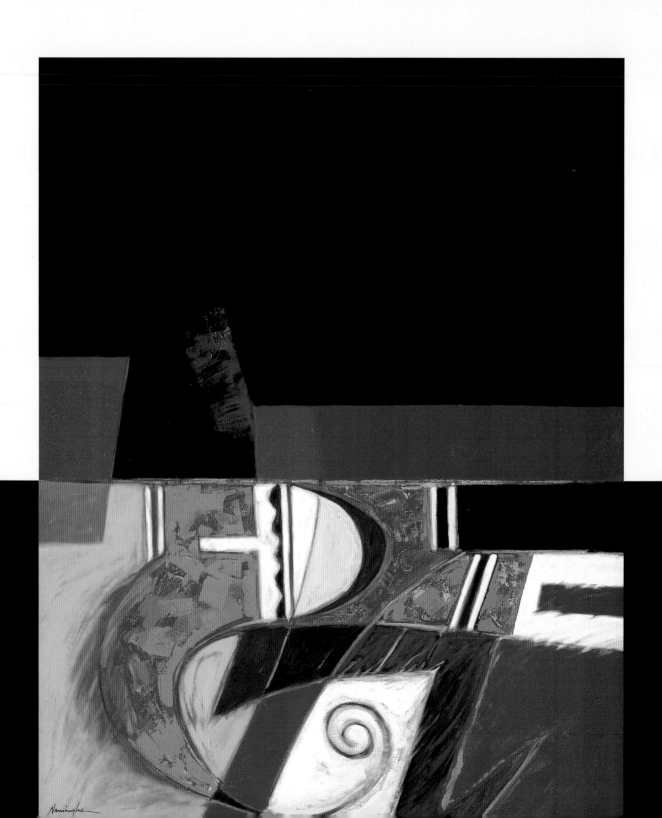

Contents

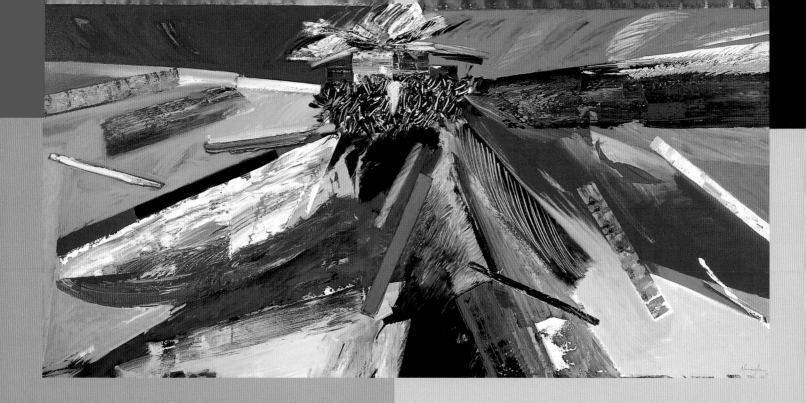

CEREMONIAL HAWK KACHINA. 1991.
Acrylic on canvas, 60 x 120". Collection Jan
and Peter Chapman.

"What I've done here—it's one of my
larger paintings—is to make the image of
the kachina hawk dancer as minimal as
possible, with only a few key details mak-
ing up the face and headdress. I wanted to
suggest the energy of the dance. I have
emphasized the wings of the dancer and
given a hint of a landscape in the upper
part. I was after naturalistic and rhythmic
movement. There's a set rhythm to the
song that accompanies the dance. Yet
there are breaks to the rhythm, especially
when the dancer moves down or up or
swings from side to side. The brilliant color
I'm using represents the strength of that
kachina."

Dedication

To all living artists—the mortar of civilization—who thrill us, dazzle us, and enable us to learn how to become mature human beings.

Thomas Hoving

New York City, New York

Acknowledgments

Thank you to my grandparents, Emerson and Rachel Namingha, my parents, Edwin and Dextra Quotskuyva; and to all the teachers who have been encouraging and inspirational to me.

Special thanks to my family—Frances, Arlo, Michael, and Nicole Namingha—for their support.

Grateful appreciation to the private collectors and museums for lending their work for reproduction in this book.

Dan Namingha

Santa Fe, New Mexico

Bridging the Gaps

The Art of Dan Namingha

By Thomas Hoving

Dan in his studio, 1999.

Who knows what will capture the eyes and mind of a creative person and what will become an indelible influence: powerful childhood recollections; sudden, sparklingly grand, or even trivial visual impressions; images from dreams; religious or spiritual impulses; what teachers do and say?

Inspirations vary widely from creator to creator. In the eighteenth century, Johannes Kepler was led to his discovery that the planets move in elliptical paths around the sun because of his passion for musical harmonies. Stuart Davis, the American abstract painter of the postwar period, would talk about the unexpected event that impelled him to abandon realistic subjects and paint his well-known boldly colored and dynamic abstractions. One Sunday morning he stumbled half awake into his kitchen and saw his children on the floor reading the brightly colored comics. He raced back to his studio to record the kaleidoscopic images of the bold colors and disjointed forms he'd seen upside down. "Your true teachers," Davis mused, "are what's unexpectedly around you—and, of course, what's inside you, yourself."

It doesn't seem to matter if the impetus is trivial or grand—what gets etched in the artist's mind as memorable, magical, or mysterious is what counts.

In northeastern Arizona, on the Hopi reservation not far from the village of Polacca is Hekytwi Mesa, known as Badger Mesa after the clan that for generations has held stewardship over the place. At first sight the mesa isn't all that impressive, certainly not like the painted buttes of Sedona in southern Arizona. Yet this mesa changes the more you look at it. In time it seems to grow, rising out of the flat desert landscape like some mammoth stepping-stone. It seems something constructed by man rather than geologically formed; some worn-down, elongated pyramid. Yet, the closer you get to it, the more the mesa becomes fragmented and breaks up into dozens of shapes. It mirrors the environment, continually reflecting the abrupt changes in the weather that enthrall, invigorate, and, at times, terrorize the people who live in its shadow.

That mesa and other legendary ones are fundamental influences upon artist Dan Namingha, a member of the Tewa-Hopi tribe. On the Hopi reservation there are three large mesas known as First, Second, and Third Mesa. On top of each one are several villages. Namingha's grandparents are from First Mesa, which lies furthest east from the other Hopi mesas. On First Mesa are three villages—Walpi, Sichomovi, and Hano. His grandfather, Emerson Namingha, a Hopi, comes from the village of Sichomovi and is a member of the roadrunner clan. His grandmother, Rachel, is Tewa from the village of Hano and a member of the corn clan. Since the culture is matriarchal, Dan is considered Tewa-Hopi and belongs to the corn clan. The Hopi word, *namingha,* signifies a volunteer plant that flourishes without having to be nurtured.

Dan in his studio outside Santa Fe, New Mexico, 1999.

Hano is the only village on the Hopi reservation where Tewa is spoken—all other villages speak the Hopi language. Hano was established in the seventeenth century and thus is new compared to the Hopi villages that were built around 1100 A.D. These Tewa and Hopi tribes are part

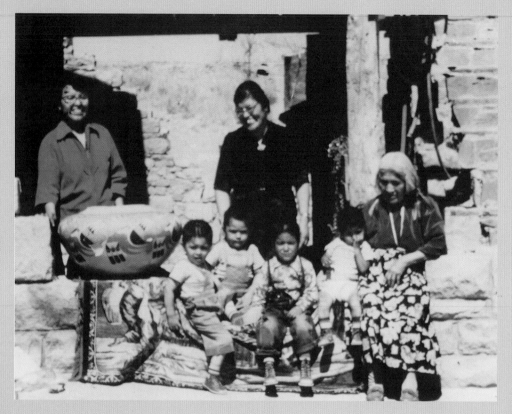

From left to right: Dan Namingha's aunt, Ruth James, Don James, Mike James, his grandmother Rachel Namingha, Dan, Reggie James, his great-grandmother Annie Healing Nampeyo; early 1950s.

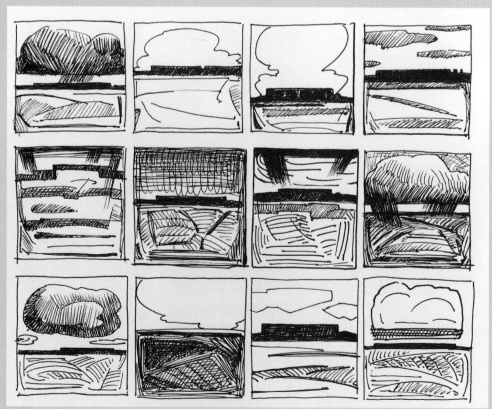

HOPI DESERT SCENES.
1997, Pen and Ink drawings from sketch book. Collection the artist.

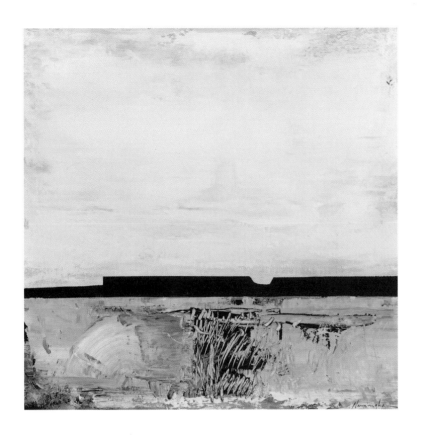

POLACCA #1. 1998. Acrylic on canvas, 20 x 20".
Collection Audrey and Norbert Gaelen.
The artist invented a technique using ordinary
tools from the hardware store.

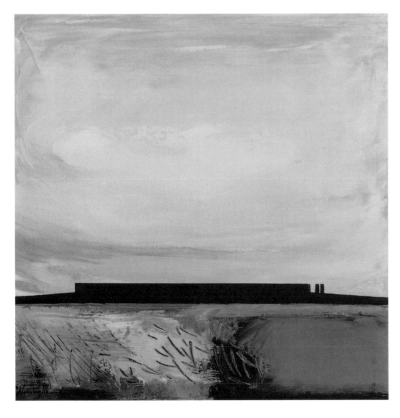

HOPI #5. 1998. Acrylic on canvas, 20 x 20".
Again, hardware tools were used for
dramatic effect.

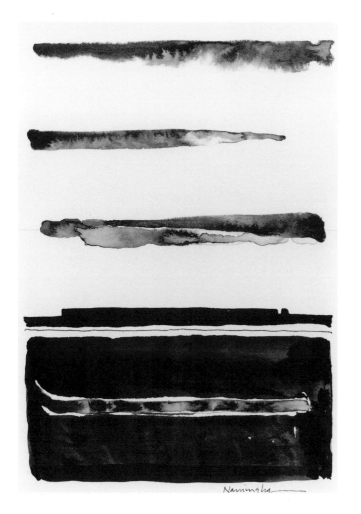

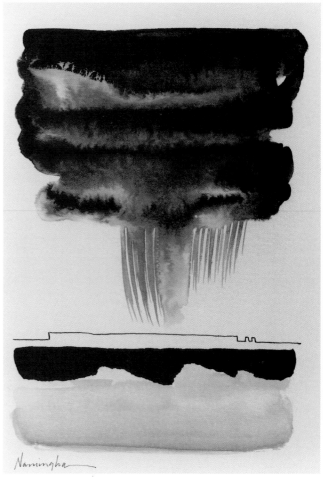

LANDSCAPE STUDY #1. 1998.
Pen and ink wash drawing, 8 x 6".
Collection the artist.

LANDSCAPE STUDY #2. 1998.
Pen and ink wash drawing, 8 x 6".
Collection the artist.

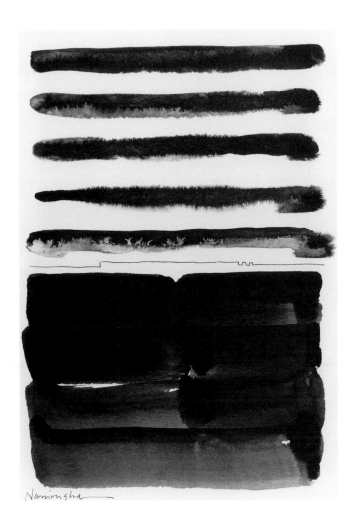

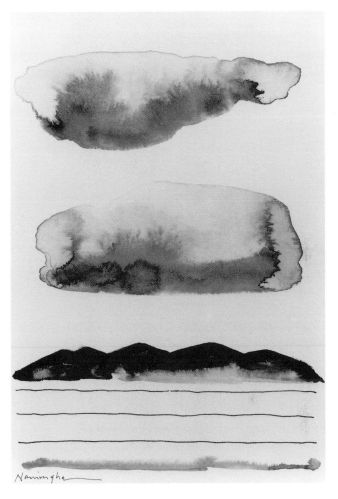

LANDSCAPE STUDY #3. 1998.
Pen and ink wash drawing, 8 x 6".
Collection Frances Namingha

LANDSCAPE STUDY #4. 1998.
Pen and ink wash drawing, 8 x 6".
Collection Frances Namingha.

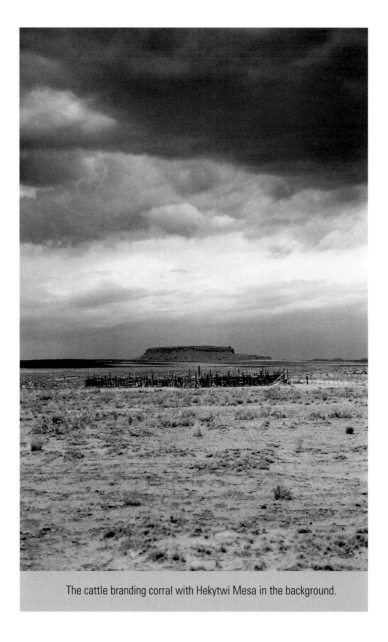
The cattle branding corral with Hekytwi Mesa in the background.

of a much larger group of ancestral Indians located in the Southwest and usually known as the Anasazi.

The Tewa were originally from the Rio Grande region of Northern New Mexico. During the seventeenth century a band of Tewa migrated to Hopi to help defend the people of First Mesa against raiding tribes. The Hopi and Tewa became allies and fought against their enemies, proving to be effective and successful. Because of their success as warriors, the Tewa were allowed to build on First Mesa and were granted lands below the mesa for farming. In the eighteenth and nineteenth century members of both tribes began to intermarry.

At the end of the nineteenth century families began to move off the mesa to the farm areas. One village was

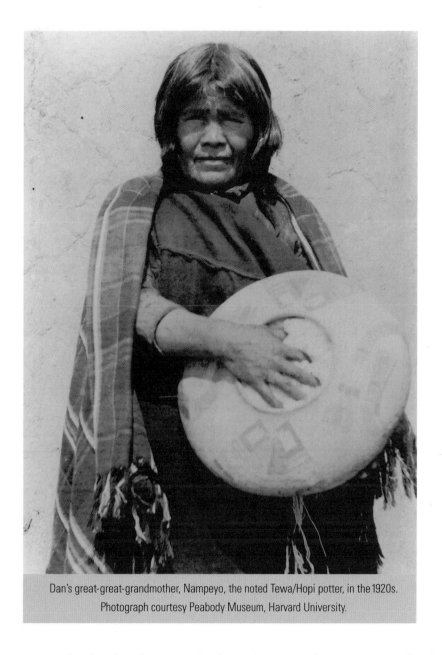

Dan's great-great-grandmother, Nampeyo, the noted Tewa/Hopi potter, in the 1920s.
Photograph courtesy Peabody Museum, Harvard University.

founded with a government school and trading post. In the early twentieth century, more families, including Namingha's grandparents, moved down and the village of Polacca was incorporated.

Namingha, who was born in 1950, has jet-black hair surrounding a powerful square face. He looks out at the world with a certain inscrutability that disappears with a ready smile when he is excited or amused. He likes to tell about his background because it is deeply imbedded in his art. He was born on the Hopi reservation and grew up in Polacca. His mother, Dextra, was working as a nurse in Tacoma, Washington at the time, but returned to Hopi for his birth. Dan never met his biological father and knows little about him except that he

was Hispanic. From infancy, his grandparents, Emerson and Rachel Namingha, raised Dan, while his mother continued working as a nurse off the reservation sixty-five miles away in Winslow, Arizona. His grandfather was a stonemason, rancher, farmer, and carpenter who revered art.

Hekytwi Mesa dominates the view from Dan Namingha's grandparents' front door. It is one of his most durable and powerful impressions and it lies embedded in virtually every work Namingha has created. As a child he'd ride in the family pickup truck the twelve miles from the house to his grandfather's ranch past the sandstone mesa. When he was old enough he'd hike or ride on horseback. "I studied that magnificent mesa and although it didn't seem as if I took much heed of it, I drank up its every detail, mood, color, and shape and stored it away. I have continually re-created it in my works, sometimes exaggerating the mesa to give the impression one is looking through a wide-angle lens.

"On countless journeys near and around that mountain, I remember observing the textures and crevices on the walls. Sometimes they resembled figurative images. When it rained in the summer the dirt road and foothills would turn to clay that was a fascinating yellow ochre. I'll never forget it. The mesa and the surrounding landscape became intensely colorful, especially when the rain clouds broke up and the late afternoon sun would shoot a brilliant beam of light across the horizon. Then the colors became even more intense. Later on, I equated these bright colors with paint—yellow azo, yellow ochre, and cadmium orange."

NAMPEYO POTTERY MOTIF. 1981. Lithograph, edition of 100, 15 x 22". The image was inspired by the artist's great-great-grandmother's pottery. A close-up image of a key design, it has been made using the same technique as his other lithographic prints, except that a lithotine tusche wash has been applied at the center of the design.

Namingha was particularly intrigued by what happened to the rugged landscape when the seasons changed. "During the dry season the cracks and lines in the earth would resemble spiders' webs. I remember being struck by dry shrubs or rabbit brush clinging to the parched earth, all slightly bent to one side because of the winds. Today, when I find similar textures in various papers that I've either made myself or collected, I incorporate them into my work."

Namingha had the luck of being observed and discovered by a series of exceptionally perceptive teachers who for the most part let him be, teaching in the best possible way by deliberately not appearing to teach him at all. Becoming an artist was almost inevitable. Art was in his

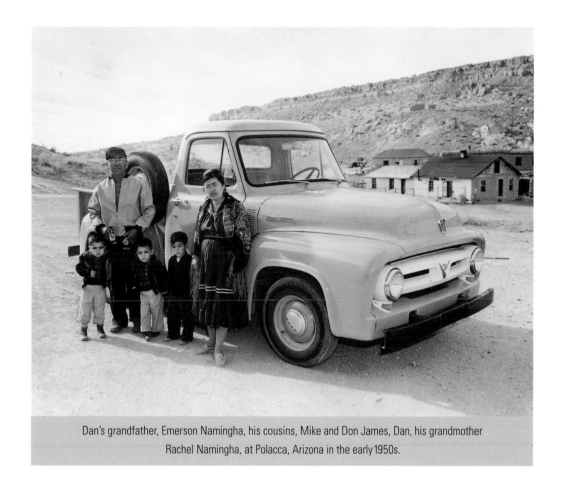

Dan's grandfather, Emerson Namingha, his cousins, Mike and Don James, Dan, his grandmother Rachel Namingha, at Polacca, Arizona in the early 1950s.

blood. His great-great-grandmother was the innovative potter Nampeyo (1860–1942), from Hano village. She is considered one of the major Native American creative forces of the past century. She revived the crisp, delicate, and refined style practiced by artists in the Hopi village of Sikyatki four miles east of Walpi and below First Mesa, which flourished from 1375 until 1625. She discovered the source of Sikyatki's fine-textured yellow clay and replaced the heavy, white, crackled Zuni slip that was prevalent at the time with a more delicate unslipped polished yellow body on which detailed drawings could be made. From the historic Sikyatki ware she adopted a breathtaking range of subject matter—birds, butterflies, stylized animals, and kachina faces, all delineated with crisp powerful strokes.

Numerous members of Dan Namingha's family were also accomplished artists. Grandmother Rachel was a potter. His mother eventually retired as a nurse and became a well-known potter herself, along with his sister Camille and several relatives. His uncles carved kachina dolls. Several cousins are potters, including Steve Lucas and Les Namingha, who were students of Dextra's. Dan's early home was filled with the family's works, every one of which he vividly recalls, and some of which he still owns.

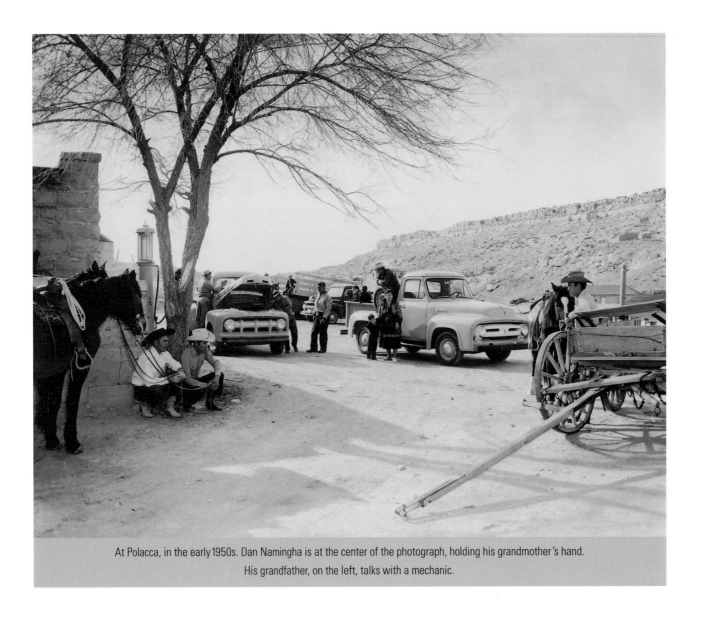

At Polacca, in the early 1950s. Dan Namingha is at the center of the photograph, holding his grandmother's hand. His grandfather, on the left, talks with a mechanic.

As a child he sketched on whatever material he could find, paper bags or pieces of wood from grocery boxes and orange crates. He was, one might say, a bit obsessed. "Sometimes when I would run out of material to draw on," he recalls, laughing, "so I sketched on the outside wall of the house until I was scolded for making a mess. To draw, I got chunks of cedar wood charcoal from our outdoor cooking oven. Whenever there was a pencil available, I drew on blank pages of the books at home and at school."

In the elementary school on the reservation, Namingha met his first formal art teacher, Lillian Russell, the second-grade teacher and wife of the principal. A dedicated Sunday painter, she worked in oils, watercolors, casein, and pastels. She customarily introduced all these materials, along with pens and pencils, to her stu-

dents as learning tools. "She was exciting to study with. Those early morning, one-hour art classes motivated me to get up extra early to get to school, just so I could be with her and experiment with the materials. I wasn't forced to learn reading to the exclusion of drawing and painting, which usually happens in early school, and so my artistic skills were never blunted. Lillian Russell didn't push me in any particular direction, and now I believe she did it on purpose. She concentrated pretty much on the materials. I got a great kick out of them. Materials have always fascinated me. She encouraged me to do anything that came into my mind with them and showed me what I could squeeze out of them. On one occasion she urged me to drench my paper with water and create a landscape using watercolors and then applying charcoal on top for detail. That was wild. I soon was mixing oils and pastels and incorporating the use of a pallet knife in place of the brush. Even wilder!

The good thing about Russell was that she never insisted I stick with standard Native American imagery or subjects or accepted styles. She allowed me to paint anything that came into my mind and I did so with abandon. From the beginning I had enormous freedom and loved it."

In the late 1950s Namingha's mother returned to her family, working as a nurse with the Public Health Service on the Hopi reservation. In 1960 she married Edwin Quotskuyva from the Hopi village of Kykotsmovi. Soon after, Dan moved in with his mother and stepfather, who became another one of his teachers. "My stepfather was an accomplished kachina doll carver and he sometimes painted. He showed me wash techniques using casein on paper."

In the spring of 1961, Dan's grandfather, who saw something promising in him artistically, bought him a set of oil paints for his eleventh birthday,

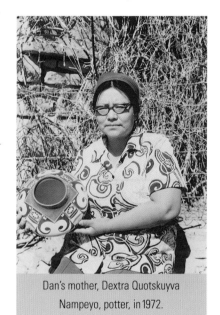

Dan's mother, Dextra Quotskuyva Nampeyo, potter, in 1972.

encouraging the boy to experiment with them. "I took to them immediately. I didn't paint on canvas—there was none available—so I painted on cardboard."

That fall, at junior high school, Namingha met another alert art teacher, Ted Parkhurst, who recognized that Dan might be an artistic prodigy. He never told him this, however, and in almost an offhanded manner, he taught Dan the basics of perspective, the vanishing point, foreshortening, and shading for depth. Even more significant, Parkhurst introduced him through books to the great painters of history, principally Michelangelo. He also encountered the works of the illustrator Norman Rockwell and came to admire them greatly for their narrative power.

"That got me to looking through the art section of the school encyclopedia and I discovered artists such as the Impressionists, van Gogh, Mondrian, and Picasso. I looked at it all in awe. We didn't have museums out

there in the desert and I was far from any major one, so the closest thing was these magnificent reproductions in books. I hardly ever remembered or cared about the names of artists I saw at the time. I was only interested in their work. It wasn't until years later when I realized what a major impression they made on me. Especially Michelangelo and van Gogh. The colors, textures, and the shapes of the brush strokes in van Gogh's work astounded me. So daring! The textures in his paintings reminded me of chisel markings in some of Michelangelo's sculpture. The power and finesse of the Michelangelo drawings blew me away. I'd try to copy them for hours. Every time I finished a detail I had learned something new. I received a real classical grounding by means of this art history "school." Copying details from Michelangelo was a perfect way to coordinate my hand and eye. There was an unexpected side effect, too, for I learned composition. You see, when you're looking at reproductions you're not looking at overall images, only the details. Because of this you begin to perceive a host of highly abstracted schemes, call them, mini-compositions. So I guess you can say I learned both realistic anatomy and abstract composition at the same time from Michelangelo."

Although he had plunged enthusiastically into art at that early age, Namingha nevertheless looked on it as a somewhat minor activity in his life. It wasn't until the age of fifteen that he became aware that he might want to become an artist. It wasn't a startling, one-time revelation, but one that grew on him by degrees.

"In the summer of 1965, my uncle, Raymond Naha visited us from White River, Arizona. He painted in the traditional style, but he introduced me to acrylics. We painted together." The medium had a profound affect on his work and Namingha becomes animated when he explains the process of working with acrylics. "Acrylic is more brilliant than oil and I was entranced by it. At first, it was difficult to control because it dried very quickly, unlike oil paint. With acrylic there was no turpentine or paint thinner required, just water. My objective, early on, was to make acrylic look like oil—a challenge that I didn't mind. Today, from time to time, I switch from acrylic back to oil paint or oil pastel. Sometimes I mix them together, applying acrylic first and allowing it to dry, then adding oil paint and pastel. When I discovered acrylic, I found it exciting because it was different. I delighted in moving it in any direction with my fingers or some cloth. The medium was durable, which allowed me to scratch and cut into the paint, sometimes peeling the paint from the surface, which added a whole new dimension. It was also very flexible. I began using this same sculpting approach with oil paint on canvas and oil pastel on paper—whether taking something away from the canvas or putting it back. I also became fascinated with scraping away pastel from paper to create negative space. It was the very early stages of one of the fundamental features in my work, creating negative spaces. In some oil pastels around 1972, I'd paint a complete image with oil paint and oil pastel and then use turpentine to rub or scrape away some of the paint. In this way I'd create what I consider a telling void on the paper."

Namingha relates an important moment in his life, which occurred when he was ready for high school and had to leave the reservation, as many Hopi young people are forced to do. "I went to Mingus High School in Jerome, Arizona, which is about 160 miles off the Hopi reservation. I stayed in a boarding school for Native American students in the small community of Cornville, about eighteen miles from Jerome. That school only went as far as the eighth grade, so the students who were of high school age were transported to Mingus by bus. There were about ten of us." As a freshman in high school he encountered another perspicacious teacher, Mel Minthorn. From the crisp sureness of Namingha's drawing and the striking aptitude of his anatomical studies, Minthorn recognized that the boy possessed a singular talent. "Minthorn gave those of us he thought might be artistically talented the materials and instructions we needed. He never restricted our artistic activities and that was key."

Because it was so far away from home, Namingha returned to the reservation within six months and enrolled in another high school, but this involved an eighty-mile bus journey each way to Holbrook, Arizona. It soon became torture. Waking up every morning at 5:30, Namingha and a dozen other students made the long trip and returned late each day. Spending too much time on the road, Namingha was glad when the school year ended.

Art wasn't the only thing he was passionate about during his years in high school. He had dreams of becoming a professional musician. Self-taught, he played lead guitar in a rock band, doing gigs on the reservation. Eventually, however, art became his primary interest, with music secondary. Other school activities included basketball and football, and during the summer months he helped his grandfather round up cattle for branding. An accomplished horseback rider, he attended local rodeos with friends and cousins on occasion. As a dare the boys rode in bareback bronc- and bull-riding events.

In the fall of 1966 Namingha was accepted into Ganado boarding school on the Navajo reservation some fifty miles from his village. "It was the tenth grade and I met another art teacher who became a major influence on me, Mrs. Kirby. I became her pet and since I always completed quickly the assigned projects she found other things for me to do, cutting mats, making frames for the other students, and various other tasks involving materials. I loved it."

This teacher was responsible for what is probably the most dramatic turning point in Dan Namingha's artistic life. Kirby collected a bunch of his works and without his knowledge sent them off to the University of Kansas at Lawrence. To Namingha's surprise, he was awarded a scholarship to study that summer at the university. "The surprising scholarship made me realize that I might really become a serious artist."

Although he never told anyone, the young man was somewhat reluctant to leave the reservation and miss

out on summer activities with his friends. His parents and grandparents encouraged him enthusiastically to leave, for the chance to get out into the wide world might not come again. The long trip to Kansas by Greyhound bus was the farthest Dan had traveled on his own, but he found that he was far from nervous; he was thrilled. The art school at the university was multifaceted, and Dan had a chance to observe teachers and students in music, theatre, dance, and all the visual arts. There was only one other Native American present, a boy from Montana, but Dan made friends with three young black students from Louisiana who were musicians and who played saxes in the jazz band and sang soul music. It was Namingha's first real interaction with people from diverse cultural backgrounds.

At Kansas, Dan received his first formal—and rigorous—art training from three teachers who had no doubts about his abilities. One was Barbara Wille, a tough taskmaster who drilled him again and again in drawing basic subjects, mostly still lifes, often using objects from the university's natural history museum. "Although I did my damnedest to get it right, and occasionally did, it was not good enough. Wille was the strictest disciplinarian I'd ever encountered. Although I didn't realize it at the time, a tough regimen was just what I needed. In time I actually found the grind uplifting."

RODENT. 1967. Pencil drawing, 12 x 16". Private collection. A student drawing, done at the University of Kansas.

Other teachers added different skills and perspectives on art, in what proved to be a coordinated curriculum.

"An instructor, Judd Scott, would pile a bunch of chairs haphazardly on a large table. Sometimes a picture frame was thrown in. It was pretty bizarre. These things were all upside down, on their sides, jammed up, and locked together. He'd demand I draw the ensemble as quickly as I could, without taking my eyes off the subject. We did these quick-drawing exercises several times; I found the task fascinating. Those chairs were all recognizable objects, but because of this nutty, chaotic way they were stacked, they became something different. They turned into pure abstract three-dimensional compositions. This teacher made us recognize realism and abstraction at the same time. At least that's the way I saw it. It was a trick, sure, but it was a good trick. I think only certain students clicked to what was going on. I'm glad I was one of them."

The exercise with the jumbled chairs would make an indelible mark on the way Namingha approached sculpture—possibly his most accomplished medium today—although he wouldn't realize it for years.

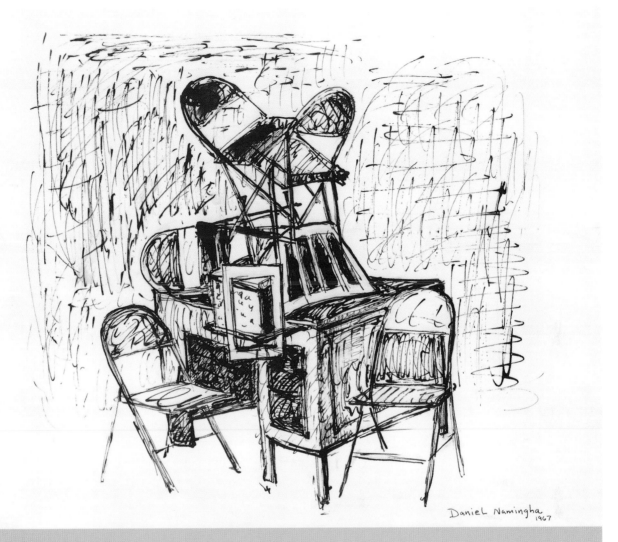

JUMBLED CHAIRS ON DESK. 1967. Pen and Ink drawing, 11 x 13". Private collection. A student drawing, done at the University of Kansas.

Another teacher, Philip Van Voorst, taught commercial art and allowed the students to make sculpture as part of the course. "In his class I created an abstract wire sculpture with twine, inspired by Naum Gabo and Henry Moore, whose works I'd seen in a book. I tied and stretched the twine across the wire back and forth, connecting from one end to the other, and then I set it into a Styrofoam base. This sculpture and a drawing were selected and included in the student group exhibition at the end of the school session."

All the exercises he learned from these three instructors made him feel confident and proud, but only for a short time. When he tried to introduce the feeling of simultaneous reality and unreality into the subjects that he was painting, he couldn't. He admits to becoming somewhat insecure. "I struggled for a long time over how

to depict realistic elements in a semi-unrealistic or impressionistic way. Curiously, while I was grinding away without success, I did have this implausible, but heady, feeling of elation mixed with frustration because of my inadequacy. The sheer challenge made my blood race. It was a serious and important moment for me. Although at first I didn't know how to get the work right, the struggle taught me how to persist and get it partly right, if not completely. That was another important turning point for me."

Dan as a student at the Institute of American Indian Arts, Santa Fe, New Mexico, 1968.

After completing the summer session at the University of Kansas, in the fall of 1967, teacher Kirby pushed the young artist even further, this time into the Institute of American Indian Arts at Santa Fe, New Mexico. Only five years old at the time, the school from its beginnings had proved to be a fertile training ground for gifted Native American artists. The Institute had both a high school and postgraduate program. It was the only place in America where students could learn about art unfettered by stereotyped Indian art subject matter and styles. "It was a free-for-all, and I liked that," Namingha says. "Anything that came into your mind was fine by the teachers. I got my hands on virtually every artistic material that had been provided."

He attended the school as a full-time student, taking formal art courses in commercial art, drafting, architectural drawing, photography, two- and three-dimensional design, and painting. Other courses included math, science, English, world history, and Native American studies.

At the Institute, another adroit mentor made a strong impression on him, the legendary Lloyd Kiva New, a Cherokee and one of the founders of the Institute. New, a vigorous visionary then in his early fifties, was an accomplished painter, printmaker, and fashion designer. He was obsessed with having a central training ground where youngsters from all Indian nations could express themselves without restraint and without having to grind out native cliches.

"He hated anyone telling us, here's the way an Indian looks and this is the way you have to make him look," Namingha vividly recalls. "His dream was to recruit Indians from diverse places such as reservations, urban cities, from the West Coast to the East Coast, northern plains to the southern plains, southwest and Alaskan natives with differing backgrounds, hopes, and dreams. The goal was to give us expressive freedom. It was a combination of a strict, traditional art school, with academic training in all disciplines of the arts."

Rock music, psychedelic light shows, and happenings were part of it, too. This was the Sixties after all. At the Institute, some of the students engaged in the same boisterous and productive intellectual turmoil that

was sweeping across America. Namingha found himself caught up in unending discussions about tribal backgrounds, life on the reservation, the Vietnam War, progress and lack of progress in civil rights and, above all, the gross mismanagement by the Federal government of Indian affairs. Along with intellectual pursuits, Namingha played in the campus rock band, doing gigs on and off campus in dance halls and elsewhere.

"What was most invigorating to me was the broadening of my vision of the world, which had been so restricted. The Institute wasn't only for visual artists. There were dancers, poets, writers, actors, filmmakers, and musicians. The Native American composer, Louis Ballard, who had won a Pulitzer Prize, was a music instructor. His specialty was to take a simple and direct piece of traditional Native American music and transform it into a highly complex composition with multiple octaves performed by the Institute choir. Although I was not a student of his, I was much exposed to his work, and while I didn't realize it at the time, his technique was tremendously influential on my later work."

An instructor who made the strongest impression on him was a Hopi woman, Otellie Loloma, who taught painting and ceramics. "Unfortunately, I didn't take her ceramic course. I suppose I didn't have the specific interest at the time. I was assigned to her advanced painting class and began my first year learning the proper way to stretch canvas and linen, and to correctly prime the material by applying gesso or rabbit skin glue. She basically allowed students to paint whatever they wanted, and I started by painting realistic landscapes. She'd take a long look at my work and simply say that's good and walk away. At other times she wouldn't utter a word, which left me puzzled. I was hoping for some dialogue about my paintings. Eventually, she began asking me about Hopi and life on the reservation. It turns out she was from Shipaulovi, seven miles from my home."

As the year progressed Dan's landscape paintings became repetitive and routine. He got bored and needed a break. Loloma saw his struggle and steadily probed into the core of his artistic thinking by asking him to reevaluate his work and to begin experimenting. "I started with simple blends of color taken from the sky of my landscapes. I worked with that for a while, then slowly moved toward flat solid colors. The paintings eventually became nonobjective. Otellie continued to encourage me to experiment, so I incorporated other materials into my paintings. I began by gluing strips of canvas and linen onto stretched canvas and painting over them. In another painting, I glued sand onto the canvas and painted over it. I remember taking wooden tongue depressors, which were used to stir paint, and gluing them to the canvas. One day I took some of my realistic landscape paintings and began painting over them with broad slashes of color, at the same time randomly sticking objects onto the surface.

"Another time I got the idea to incorporate Hopi symbolism into a couple of my nonobjective paintings. I wasn't quite sure how that would fit into the composition; it was the beginning of something I was unclear

about. Otellie encouraged me to pursue it further, but I couldn't figure out where else to take it, so I left the idea for the moment. I was young and not quite sure where this was all leading, but I liked the radical change and the idea of the unknown."

Namingha now realized that, for him, experimentation was the key to unlocking his creative imagination. Loloma encouraged the students to observe one another's work, to share and discuss ideas with one another. Her method was not to mold the students into what she wanted, but to allow them to mold themselves. She told Dan over and over, "create, create, and recreate and never be afraid of experimenting, for that's how you'll find your own unique artistic direction." He never forgot it.

This was in the spring of 1969, a couple of months from high school graduation, and Dan now began to think about what to do next. For, despite the welcome changes in his work, he was filled with uncertainty. Another Institute teacher, Kay Weist, who was an architect, photographer, and commercial artist, liked Namingha's illustrations. Seeing his frustration, she suggested that he put an end to the agony and become a commercial illustrator. She helped him obtain a tuition grant at the American Academy of Art in Chicago, which specialized in the field. He decided to go, although he wasn't at all convinced that he wanted to restrict himself only to making illustrations.

After graduating from the Institute of American Indian Arts, Dan returned to Hopi for a brief visit with family. "I was nineteen and in limbo, so I decided to see the wide, wide mysterious world, at least the world of Chicago. I took the bus from Holbrook, Arizona and was several days on the road. As we drew near the city and I caught sight of that fabulous skyline, I could only think of a science fiction film that I'd seen several times. It had a scene of a shimmering city hovering in the sky with a network of tubes through which people were transported. The day I arrived was overcast and foggy, and the freeways and incredible architecture of Chicago off in the distance made it seem exactly like the movie."

The bus depot was on State Street, and Dan had an address for the Bureau of Indian Affairs, where he had to report to get an address for lodgings. He'd been told to take a taxi. Someone had described what a Chicago taxi looked like, but hadn't told him the secret of how to get one to stop. Namingha stood outside the depot for what seemed like an hour as dozens of yellow cabs streamed by, not knowing that he wanted them to stop. Then a man and a woman came out of a nearby diner. "The guy pulled out a newspaper, waved it, and, by God, a cab stopped. They got in. I followed them in, not knowing any better. The woman freaked out to see this Indian jump in after her, and naturally the guy threw me out. At last I got a cab for myself—it took another hour or so—and eventually I made it to the Bureau. From there I was sent to the YMCA on the West Side in a skuzzy part of town where, actually, I flourished."

Within three months, Namingha knew that illustration work was not for him, despite his teachers being enthusiastic about his skills. On his own, he stumbled on another landmark influence in his creative life, the magnificent Chicago Art Institute. No one had told him that in the center of this metropolis was one of the premier repositories of art in the United States.

"Visiting the museum set the tone and direction of my entire career. I walked into those marvelous galleries and knew I had to become a serious painter. It was the first original contemporary art I'd ever seen and I was blown away. It's funny, but like the art books I'd seen years before, I hardly remember the names of the artists. I cared only about the works. Oh, I recall vaguely some Old Masters. But the Impressionists and that incredible Seurat *Grande Jatte* stunned me. And the brushstrokes of Monet were so fluid that they seemed almost like running water, all moving in one direction. The softness of the paint got me, too, especially how leaves and flowers became so soft on the edges. The swirls of paint of the sky in a landscape by van Gogh were so fearless! I was also moved by Picasso, and particularly by the hardness of his forms. I was astounded to see those blocklike forms. But I was even more overwhelmed by the paintings by Franz Kline, Robert Motherwell, Mark Rothko, and Jackson Pollock. I'd known of the abstract expressionists from books, but I'd never seen the paintings for real. I was shocked at their power and sheer size, but even more by their delicacy and finesse. I was also astonished to recognize distinct parallels of certain design elements in these works with those of my own culture and tribe. It was only later that I learned the reason for these striking similarities. Abstract expressionists, Pollock and Gottlieb especially, had been influenced by Native American work. Only they had quoted our elements without understanding their meaning.

"I was impressed with Franz Kline because his brush strokes were so aggressive. I was taken with Rothko because his color fields radiated light but possessed a distinct softness. I found both de Kooning and Pollock exceptionally eloquent in a purely literary sense. I was shocked by what I saw in the Chicago Art Institute. It was so radical. As I walked through the modern galleries of the Art Institute, I realized that artists throughout history had been struggling to create more minimal works. From that moment on, things started clicking for me artistically. Although I was overwhelmed and inspired by the work I saw, I couldn't figure out what, specifically, to do next with my art. I was reminded of my experimental paintings in Otellie Loloma's class. I began to procrastinate. Utterly frustrated, I gave up painting altogether. I was still young and decided to take a break, I had to get away, had to do something else, had to ponder my creative life, let things simmer, see another world."

The world Namingha impetuously chose in 1969 at nineteen years of age was the United States Marine Corps. That hardly seems the place to come to grips with fine art, but it worked for him. In Marine boot camp,

he was hazed and hassled unmercifully by the stereotypically physically brutal and profane drill instructors. One throttled and beat him as he growled mockingly in Namingha's face that, "the only good Indian is a dead Indian." Yet, Dan came to admire everything the Marine Corps is famous for—the discipline, the unexcelled morale, the polish and style, even the rugged hazing of boot camp. After basic training, he was shipped off to Hawaii with a unit stationed at Kaneohe Marine Air Base for further training. After about a year he was issued new orders—First Marine Division, Da Nang, Vietnam. But when he arrived in Okinawa for processing, his Vietnam orders were canceled, and he was reassigned to the Pacific Fleet Marine Force in Okinawa. There, he continued training in counterguerilla warfare, and then went on to Mount Fuji, Japan, for cold weather missions.

While in Japan, he received a weekend pass and decided to visit Tokyo. "The U.S.O. Center directed me to some important sights to visit. One was the Tokyo National Museum. The collection was overwhelming. I was especially impressed with the woodblock prints created between the seventeenth and nineteenth centuries. The beautiful blends of color and wonderful narrative images were inspirational. Those artists were truly masters. I also noticed a parallel between the Japanese and Native American culture. The idea that art is not separate but an integral part of life."

"My time in the Corps gave me the precious opportunity to think. I spent hours analyzing what my art should become and one day it just came to me. Suddenly, I knew that my artistic mission was to transform the subject matter of Native American art and its customary realism into an abstract, almost minimal, form. I got it one day in the heat, sitting on that strange island of Okinawa. Imagine! I also knew that when I got out of the Marines I had to get into the right environment, one that was full of artistic power and was receptive to artistic sensitivity. That could only be Santa Fe—at the Institute. After spending a year in Asia, I left the Corps in 1972, returned to the States, and went straight to Santa Fe, hoping that something would work out."

In those days, the now bustling art, cultural, and tourist mecca of Santa Fe was a modest, sleepy town. Only about four galleries existed in what is today's crowded downtown art scene. The fine museums that grace the city today were dreams. Canyon Road, today a sprawl of art galleries, was the home of a few artists' studios. Namingha went back to the Institute to see what his former instructors were up to. Loloma, typically blunt, asked if he was just dropping in or planned to stick around and start functioning. Dan, nonplussed but buoyed, told her that he was looking for part-time work and wanted to find a studio somewhere.

She suggested that he enroll in the Institute as a postgraduate for the three remaining months of the school year. Lloyd New was overjoyed to see him. He set aside a studio and arranged for a modest scholarship to cover his room and board. In exchange, the only thing Namingha had to do was to take a few art history courses, which he eagerly looked forward to. He had to show up twice a week for them and the rest of the time he was free to paint.

CLOUD SPIRIT. 1969. Acrylic and sand on canvas, 18 x 24".
Private collection. An experimental painting.

"Otellie gave me an order, 'Whatever you do, do what pleases you.' In time, I was allowed to cut the art history down to an hour and I painted sixty, seventy hours a week. I was unstoppable, working ceaselessly to get back my artistic coordination, the very feel for painting. People who aren't artists don't realize that there's a distinct feel, coordination, and balance in the act of painting. It's very physical, something like athletics. It's the exact feel of the brushes and the precise way you apply paint—feel and movements. You have to practice all the time; you have to exercise to limber up your arms, hands, and fingers. Even the Old Masters had to do it. For three months—almost without stopping—I worked on little other than regaining my coordination and the feel. Was I obsessed? Yes, but after a while, I began to feel that old sureness coming back. I started with the basics, painting highly realistic subjects, using intense natural colors, and manipulating the brush to capture the feeling of realism. Pure realism was not what I wanted to do in the future, mind you. I was going through a process. I figured that once I felt comfortable again with naturalistic subject matter and style, I could make the transition to what I was dreaming of doing—a combination of realism, abstraction, and minimalism."

Getting back into the feel of painting, Namingha felt supremely confident. "In the Marine Corps, the sense that you can do anything is drilled into your bones. You're taught to be proud of accomplishing every task smoothly and swiftly. In the Corps you gain a mental confidence in yourself and what you can do in almost

below left, top:

FETISH SHIELD. 1975, Acrylic on canvas, 30 x 48". Private collection. The oval shape represents a shield with painted feathers. According to Hopi mythology, Spider Woman, a deity, has two grandsons who represent guardian spirits. The two small figures are the artist's interpretations of them attached to the shield as protection.

below left, bottom:

MASK ASSEMBLAGE. 1978. Lithograph, edition of 100, 20 x 16". Here, the artist assembled three fragmented kachina images and broke them into vertical and horizontal lines and solid black abstract forms. He wanted to create a strong contrast between the black ink and the beige colored paper. The splattering technique was achieved with airbrush. "Sometimes when I look at a dominant color I begin defusing it by making smaller blocks of that same color." This lithograph is part of a series of prints begun in 1975 at Tamarind Institute. Namingha has periodically made lithographs over the past three decades.

below right, top:

HEMIS FIGURE. 1979. Lithograph, edition of 100, 12 x 10". This figure is an impression of a wood carving depicting the Hemis Kachina. The, sun, cloud, desert flower, and water insect symbols are represented on the headdress. This image represents the rain. He wanted to give the impression of rain clouds of a summer storm forming in the background, creating a contrast between the storm and image.

below right, bottom:

CORN KACHINAS. 1980. Acrylic on canvas, 56 x44". Collection Dan Prall. These kachinas represent the growth of corn. "I wanted to show them representationally but with elements of abstraction in straight vertical and horizontal lines similar to the Pueblo paintings."

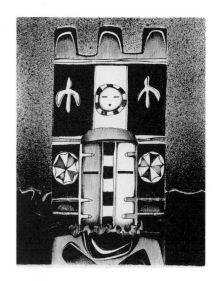

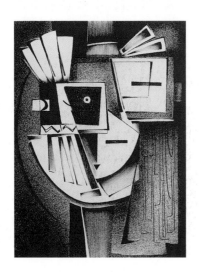

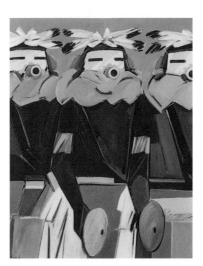

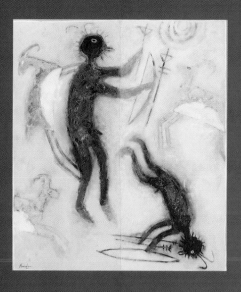

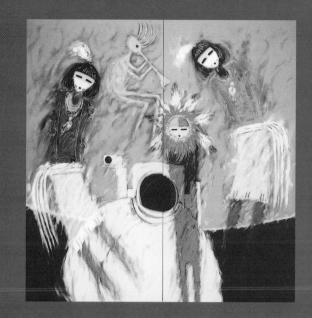

SUPERNATURAL HUNTERS. 1982. Acrylic on canvas, 80 x70".
Collection Museum of Fine Arts, Museum of New Mexico, Santa
Fe. The hunters were inspired by a Mimbres pottery design,
which originated in a Pueblo culture that thrived in the south-
western part of New Mexico from about 1000 A.D. to 1200 A.D.
Here, the design of the figures and animals moved the artist,
and he wanted to give the impression of these images suspend-
ed and floating in time and space in the spirit realm. In the early
1980s, he executed a series of paintings based on the designs of
the Mimbres culture.

Upper right:
EMERGENCE. 1985. Acrylic on canvas, 80 x 80". Collection
National Aeronautics and Space Administration, Washington,
D.C. "I was invited by NASA as a guest artist to witness the lift-
off of the Discovery shuttle at Cape Canaveral, Florida, in 1985.
Afterward, NASA commissioned me to create this painting for
their collection. Emerging from the lower part of the painting is
an astronaut in free flight in space. The Kokopeli figure (the
hunchbacked flute player) at the top signifies fertility and germi-
nation. The two figures on the left and right represent guardian
spirits, the grandsons of the (deity) Spider Woman. The figure in
the middle represents the Sun Kachina. The oval shape in the
background stands for the Earth. The title *Emergence* relates to
mankind's continuing migration, now evolving into space. The
idea was to merge ancient and current technology."

Above:
DREAM STATE. 1999. Monotype, 20 x 15". Collection Frances
Namingha. This monotype print relates to Namingha's Dream
State paintings. Namingha enjoys creating monotypes because
of the spontaneity of the technique, which makes them more
like paintings than lithographs, which are more technically
demanding and involve a lengthier process. The artist began
making monotypes in the late 1970s and continues to do so.

every area. The Marine Corps experience is far more a mental than a physical experience—not many people realize that. After what I'd gone through in the Corps, how could painting possibly worry me? In Santa Fe, back in the Institute, practicing hour after hour, I gradually felt at ease. I began pursuing where I left off in 1969, the idea of incorporating Native American symbolism into my paintings. I also realized that I could take painting anywhere I wanted. Ideas were hatching every day, and I knew I could execute them without anxiety. I'd mess up from time to time, sure, but I knew that I was steadily forming the combination of realism and minimalism I was seeking. I was no longer anxious about going all out for it. And I finally delivered it in a series of canvases, which looked like nothing I'd ever created before."

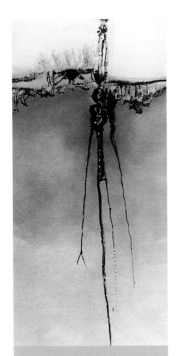

PEYOTE ROOT. 1972. Acrylic on canvas, 30 x 15". Private collection. This painting was exhibited at the Philbrook Art Museum and won an award in the professional category while Dan was still a student.

Otellie Loloma was overwhelmed by Namingha's energy and the dynamism of his new, experimental works, with their singular combinations of naturalism and abstraction. Convinced that he was getting ready, she hectored him into entering a competitive exhibition of contemporary artists at the prestigious Philbrook Art Museum in Tulsa, Oklahoma. She suggested that he send his works under the category of "professional artist." Namingha decided to send only a single work.

"The piece was different, a little strange, and spiritual. I called it, *Peyote Root.* One day I was thinking about the diversity of Native American tribes in North America and their various ritual practices, and it came to me that they have one thing in common, a connection to the earth. My piece was a root plunged into the ground with a vast sky above. I wanted to express a mystical and simultaneous separation and linkage of earth and sky. The idea symbolizes the spirituality of the Southern Plains Indian tribes who use this particular plant in their rituals. The root is the bridge between the physical and the spiritual."

Namingha's subject matter and work had always been spiritual, intimately linked to the religious beliefs of the Tewa-Hopi civilization. But specifics were appropriately disguised so that no procedural aspects of rituals were revealed.

"I had begun incorporating elements of Hopi and Pueblo symbolism in my work in the late 1960s, and they continue to be a part of my paintings and sculpture today. The spirals are migration symbols found in petroglyphs throughout the southwest left by our ancestors. They refer to the evolution of man and his birth in Sipapu, the center of the earth, from which we all emerged into this world. When the Hopi people emerged from the underworld, before they could set foot on present day Hopi, they asked permission from Masauu, the guardian deity of the

earth. Before allowing the people to have stewardship of the land, he laid out the rules; take care of the planet, nurture the crops faithfully, perform the ceremonies, and never forget me in your prayers and thoughts."

For Namingha, spirals signify the umbilical cord back to the underworld place of birth, and they represent the continuous evolution and movement of man. This shape also refers to the continuing migrations of the ancient peoples, as

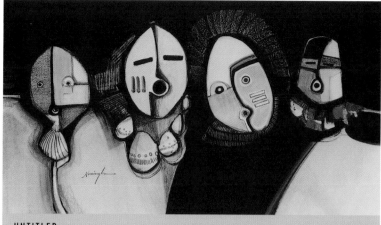

UNTITLED. 1972, Oil pastel on paper, 12 x 22". Private collection. "I assembled elements of images from various cultural groups—African, Alaskan, and Pueblo—and abstracted them. I was thinking of the parallels and similarities among cultures throughout the world, masks that may represent spirits and emotions."

settlements were abandoned and the groups moved on. Then there's the swastika, which represents the four directions, and also suggests the migrations to north, south, east, or west. He also uses a spiral with a tail that creates another spiral at the other end. This signifies the journey of man back to the central place, and it proclaims the relationship of the past to the future and the future to the past. To the Hopi, the place where they live may be barren desert—the last place anyone would want to live—but it is the source of spiritual strength.

As Namingha puts it, "You have to be strong because of the harshness of the desert. You have to make it flourish with whatever you can grow. There are no streams or rivers—only brief rainfall. That's why our monthly ceremonies are so essential. For each month there is some kind of ceremony in homage to the toughness and harshness of nature.

"The first time I ever attended a kachina ceremony was with my grandfather. I was about seven or eight years old. I had no idea of what to expect. There must have been fifty or more participants. I never saw anything like it; the only kachinas I had seen until that moment were small wooden carvings. As a young kid I was mesmerized by the appearance of the kachina dancers and their chanting as they moved. My grandfather explained to me that they came from the mountains west of Hopi known as the San Francisco Peaks. They were spirit messengers representing goodness, clouds for moisture, and a blessing for the people. He told me there are more than one hundred different kinds of kachinas, each representing something important in our lives, such as rain, snow, plant life, and animals. My grandfather continued to introduce me to other ceremonies, which are sometimes held outdoors in the central plaza of the village or inside a ceremonial chamber known as a kiva."

Among other ceremonies that impressed him were the so-called social dances, seasonal celebrations. One of these was the Butterfly Dance, in which a young woman chooses a young man to be her partner. Both the Hopi and Tewa have their own versions of this ceremony.

"Songs created for the ceremonies are special, some are new, others are ancient. Sometimes when I listen to the words in the songs I begin creating visual images in my mind, which generate ideas for paintings. When I got older I became a participant in the same rituals I had witnessed as a child and I began to have a deeper understanding of them. Because of my personal experiences, the ceremonies became a part of me. I take elements from them and incorporate them into my paintings or sculpture, which I then fragment and make abstract."

In developing his subject matter, which took years to achieve in its present mature form, Dan Namingha found that Hopi beliefs became central to his art, even when they were largely camouflaged. These beliefs were expressed by the artist through five basic elements—the landscape of the desert, the Hopi kachinas, and the concepts of fragmentation, duality, and passage—at times all mixed up together in the same work of art (rather like the way Namingha mixes up his materials).

One of the basics of Hopi belief is the division of time and space. There is also a division between the upper world of the living and the lower world of the dead. The Hopi believe that the sun has two entrances in two kivas, placed at each extremity of the sun's daily course. In the morning the sun emerges from its eastern house, and in the evening it descends into its western kiva. During the night the sun travels under the surface of the earth and rises from its eastern home the next dawn. To the Hopi, day and night are reversed in the upper and lower worlds.

So, day and night, life and death, summer and winter are seen to be not opposites but linked in continuity. Death, for example, is a birth into a new world. The spirits of the dead return to this world as kachinas that take on a cloud form. They are in essence cloud people—and their spiritual essence, a liquid known as *navala*, appears as rainfall. Everything in Hopi belief focuses upon rainfall, which, when combined with mother earth, gives birth to the essence of all things. Because of this belief, *navala* stands also for the individual human being, conceived of as a liquid. Hopi say, "I have the liquid essence of my fathers."

By means of the saturation of the earth by rain, corn bursts forth and, thus, the kachinas' *navala* helps to create human beings. In their prayer offerings to the kachinas, the Hopi "feed" them. The kachinas reciprocate by feeding the Hopi with rain so that crops will grow.

In many of Namingha's paintings and sculpture, fragmentary, almost cubist, kachinas appear. "I intend them to be intermediaries between spirit and soul. Another aspect of fragmentation, for example, relates to foreign-

ers visiting Hopi and witnessing one of our ceremonies. They may not fully understand what it represents, but they can become strongly connected to it. They are only getting a glimpse or fragment of our culture, but this also applies to me whenever I travel to other countries and visit another culture. So the negative space in my work signifies the mere glimpses at kachinas that the general public gets. That's why I invariably depict kachinas in my work as fragmentary.

"The other aspect of fragmentation in my work comes from our first contact with Europeans. That impact gave birth to an overall state of fragmentation in our culture. Some of our ceremonies were shut down, branded as heathen rituals. Some of our people were terribly abused; we had to take some rituals underground. Long ago, all ceremonies were celebrated in the full outdoors, but after the Europeans came they went largely underground and remained secret, which they do until today. In the process of becoming hidden, some rituals were lost and forgotten. Yet we still render homage to them because we feel that they still exist elsewhere."

Living in two cultures simultaneously as he does, Namingha explains that he is constantly made aware of the dual nature of all things. He began working with these concepts of fragmentation and duality because he thought about how the culture of his own people, the Tewa and the Hopi, had been fragmented since their first contact with Europeans. "Then I realized that this fragmentation had always gone on, long before that, because of our migrations over the centuries. From there, it was only one step further for me to recognize that this disruption was universal. It's not only my people but all peoples of the world who are fragmented by time and change."

The presence of the two cultures, he believes, also makes him feel sensitive to the dual nature of all things—night and day, past and future, then and now. He's convinced one cannot exist without the other. "I try to express those feelings in my work. I often try to create landscapes in my mind. The center is where you see the partial images and negative space and what I call the vital passageway. In our ceremonies and, in fact, in any cultured, spiritual ceremony, you have some sort of altar or shrine that imparts solitude, peace, and connectedness—each one is a kind of passageway. At our Hopi shrines we put in corn pollen, corn meal, and prayer feathers, and we pray for family longevity, health, bountiful crops, good rains for summer, great harvest in the fall, and for a balanced universe. The passageway I'm referring to is from the physical to the spiritual and back again. Every culture has that. Many of my new works relate to that essential passageway. Passage pertains to the spiritual as well as the formal aspects of my work."

The painting, *Peyote Root,* that Dan decided to submit to the exhibition at the Philbrook Art Museum in Tulsa was accepted. Moreover, he won a special award for it. That was when he thought he might really make it as a

professional, not an illustrator but a fine artist. The same year, 1972, Namingha married Frances Garcia, a vivacious, amusing, and intelligent young Tewa woman from the San Juan Pueblo, who had a talent for organization. At first, the couple lived in a small house in Espanola, twenty-five miles north of Santa Fe. They walked a financial tightrope. Dan worked part-time at a bronze foundry in nearby Tesuque and painted in the evening late into the night on the kitchen table—virtually the only piece of furniture other than a bed that the couple owned.

As he painted, Dan experimented, striving to achieve a desired minimalism, which he hoped would merge realism and abstraction into a powerful expression of his native heritage. "Experimenting allowed me to keep my creative options open. Also, working at the foundry, I was able to obtain wax and I began coming up with ideas for sculpture. Most of my paintings are, of course, two dimensional, but I had this growing urge to make them three-dimensional. The only way I could achieve that was through sculpture. In both my paintings and sculpture there would be a certain idea I was trying to reach, and in trying to get it, I tried to remain open to the unexpected. To another artist, the unexpected might seem like a mistake but not to me. Once I saw something intriguing, I'd go off in a new direction. I'd forget what I was working at because this unexpected thing would excite me more and I'd shoot off in that direction. I still apply that rule—I try to keep my vision open to new directions. It is the basis of my technique, and it allows me to open doors within my creative process. I get one idea and follow it for a while, and then I veer away from that initial idea and shoot off into branches of myriad ideas. Sometimes I get almost schizophrenic because I'm trying to grab all the ideas and execute them at once."

Namingha was twenty-two that summer when another seemingly fortuitous event changed his life. In Santa Fe one morning, for no special reason, he dropped by the Margaret Jamison Gallery, a sophisticated gallery devoted to contemporary artists. He didn't meet the owner but struck up a conversation with Jamison's aide, Alita Wilson. He told her he was hoping to become an artist. Wilson, to be polite, asked about the kind of work he was doing. Namingha tried to describe his minimalistic, experimental creations. Wilson was puzzled.

"To show her what I meant I decided to bring in five fairly small pieces. She seemed interested in them. She introduced me to Jamison, who merely glanced at my work and didn't utter a word. When they retired into the office I could overhear them arguing over me. Jamison wasn't sure I had actually painted the works. 'He seems a little too young for this work. Well, if you like him, he's your baby, I'll have nothing to do with him,' I could hear her saying."

What Namingha had brought in were works that incorporated paint, sand, twigs, branches, and feathers in complex abstract collages based upon Hopi schemes incorporating his still-developing ideas about landscape,

the kachinas, fragmentation, and duality. "These were my kitchen-table experiments. I was playing with the materials, bonding with them, trying to gauge how the differing elements could meld. I was intrigued by the inner life of the materials. Could they, almost on their own, guide me to paint certain subject matter in a certain way? Materials have their own mystic and creative powers, you know. Take sand. It's pure texture but it's also the whole earth. Same thing with plants and twigs. You start thinking that they're just intriguing textures, and then realize they're part of the cosmos. Paint, too, is both from nature and symbolic of nature. The sand, twigs, and plants ignited my creative thoughts and helped me to compose and complete the paintings. I looked upon these materials sort of as painterly partners."

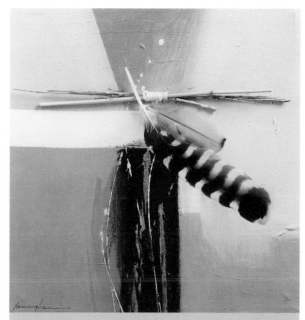

UNTITLED. 1972. Feather, branches, twigs, and acrylic on canvas, 12 x 12". Private collection. An experiment in painting to bridge the gap between realism and minimalism.

When Wilson saw the works, she told him that she'd take a chance and would offer them for sale. How much was he asking? Not knowing how to price his works, the elated Namingha told her that it depended on scale, but that they would range from twenty to forty dollars apiece. Wilson scoffed, and told him that his ridiculous price structure would have to change. Instantly, his prices changed to three hundred to five hundred dollars.

That overwhelmed him. Dan had seldom been inside an art gallery in his life. Wilson had to explain from square one what a gallery did and how they paid their artists. All his paintings would be on consignment and he'd get sixty percent of everything sold, with the gallery retaining forty percent. It sounded fine. She asked him for his telephone number, so that she could get more works from him on the very slim chance that she actually sold one. The Namingha family didn't have a phone—couldn't afford one. Dan joked with Wilson that perhaps she should send him smoke signals, and then he gave her his sister-in-law's phone number. He thought he'd never hear anything except maybe to come and get the unwanted works.

A week later he got a message to call the gallery—quickly, quickly. When he did, Wilson breathlessly told him that all five paintings had been sold. Could he bring in more and soon? Dan wasn't all that surprised; he had absolute faith in the strength of his works. He happened to have another ten small pieces and dropped them off. Margaret Jamison was there, but didn't bother to come out of her office. Another week went by and

Dan with his parents, Dextra
Quotskuyva and Edwin
Quotskuyva, in 1997.

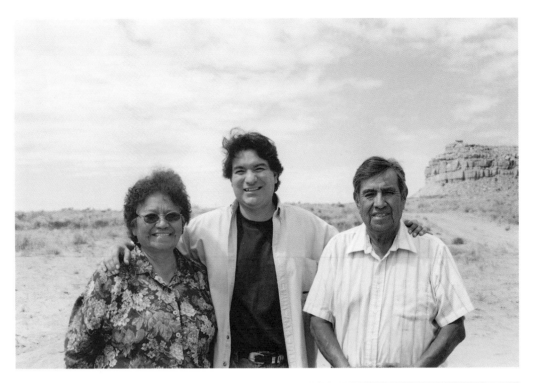

Dan Namingha, Hopi
reservation, 1997.

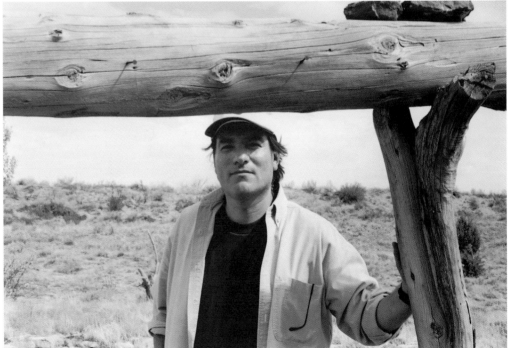

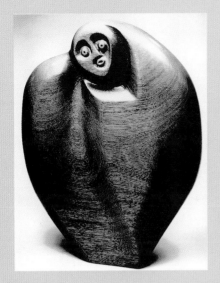

above:

SPIRIT MAN. 1977. Mahogany, 18 x 14 x 4". Private
collection. "I made a couple of wood carvings in the
1970s inspired by Northwest Coast Indian carvings."

below:

MASK ASSEMBLAGE. 1984. Bronze, edition of 20,
19 x 19 x 5". This bronze was inspired by Namingha's
early paintings of the 1970s.

right:

PALHIK MANA. 1990. Bronze, edition of 12, 16 x 2 x 2".
"I wanted to simplify the image in planes to achieve a
rich diversity of shadow and light."

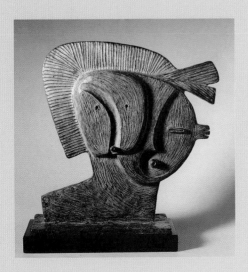

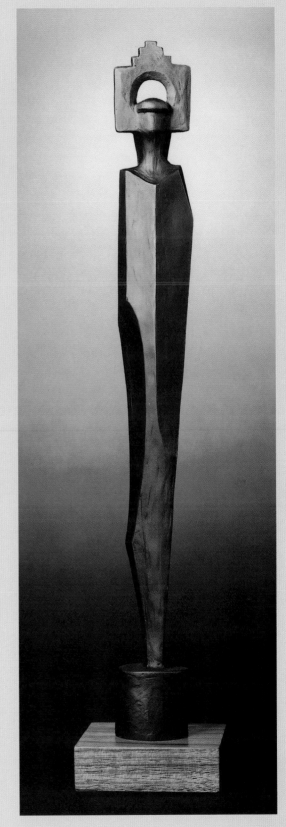

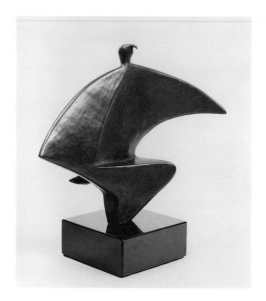

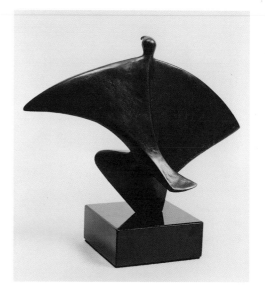

PUEBLO EAGLE DANCER. 1995. Bronze, edition of 20, 12 x 13 x 5". (Front view) This abstract image of an Eagle dancer achieves simplification gained using straight lines and curves.

PUEBLO EAGLE DANCER. 1995. Bronze, edition of 20, 12 x 13 x 5". (Back view) "The whole point was to have a tail sweeping down with movement and verve."

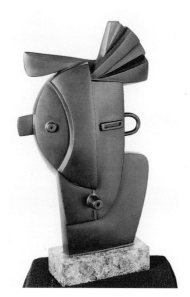

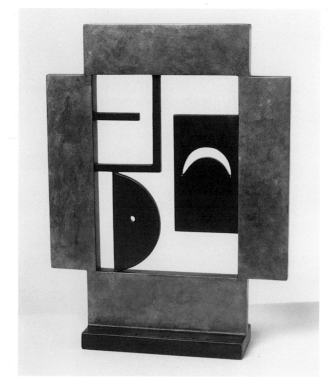

KACHINA MONTAGE. 1997. Bronze, edition of 6, 52 x 31 x 9". This work also links stylistically with the artist's early paintings.

CARDINAL DIRECTIONS. 1998. Bronze, edition of 12, 9 x 7 x 2".

another call came from Alita Wilson. The next ten paintings had sold—all of them! Did he have more? She had a check for him. "Frances and I went to a department store and bought furniture, including a table to replace the one I'd taken over for my paintings. All we needed now was a TV set and a VW bug—ha!

"I dropped the next batch of pieces off with Wilson and left. I was in the magazine store across the street when I heard this high voice pealing out, 'Dan, oh, Dan, dear!' It was Margaret Jamison wearing a fur coat and holding a small dog. She begged me to come back to the gallery and 'sit by the fire for a visit.' "

Dan was taken on officially as one of the gallery's artists and his work continued to gain recognition and the opportunity to be viewed by a larger audience. Namingha branched out rapidly. Soon numerous galleries wanting to represent him in New Mexico, Arizona, and California approached him. All gave him small one-man shows. He was launched on his career.

Today, after nearly three decades of national and international exhibitions, commissions, and honors, Dan Namingha continues to explore his world of art. Distilling the multiple subjects and themes that have influenced his artistic skills and sensibilities, he creates paintings and sculptures that are powerful and eloquent dualities. His works speak harmoniously and persuasively both in the language of his native heritage and in the brash patois of modernism. In his brilliant, many-layered paintings, he captures the all-encompassing spirituality of the Hopi outlook on man, history, and nature in a refreshingly adroit contemporary minimalism.

Front Row—Frances Namingha, Michael Namingha: Back Row—Arlo Namingha, Nicole Namingha, at Niman Fine Art, Santa Fe, New Mexico, 1999.

In recent years he has concentrated on sculpture, and creating this work now consumes much of his creative energies. His bronzes, cast in editions of eight to twelve, richly patinated, and ranging in size from four inches to eight feet, possess an uncanny sense of monumentality combined with a delicacy akin to sculptures of the High Renaissance. One finds throughout them an orderliness and a tenderness that Namingha has elevated to the highest plane of expression. They uni-

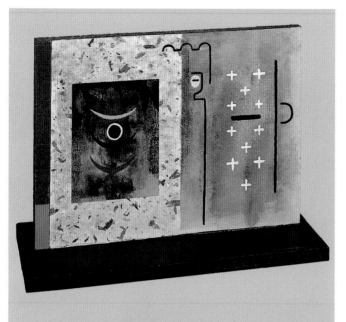

PASSAGE. 1994. Mixed media on board, 10 x 14 x 5.5". Private collection. "I was curious at first to see how my collages would look if I were to transfer them onto a wood surface. Then I began to wonder what it would look like in a sculptural format. I began experimenting with the idea in this piece. I first painted the surface, then began gluing rice paper and pastel paper on top, and then I created fragmented symbols. To me, this is much more than a painting stuck on a pedestal, because, in a way, the pedestal sanctifies it. I wanted it to be lyrical and capture what I think is the engaging and eternal feel of pastel."

On the left is a partial kachina mask—eye and crescent moons above, and a kachina eye below. The work is painted black on the back.

versally possess a sense of perfection, force, and subtlety, which imparts to them a feeling of peace and wonder.

Dan was intrigued by sculpture from his youth, perhaps because of the kachinas his relatives had carved. And although he cast his first bronze in 1975, he had not fully concentrated on the possibilities of volume, negative spaces, and color through patination until he began experimenting in 1993–94 and literally began turning collages into three-dimensional works.

One particular piece, *Passage*, made in 1994 of mixed media on board is important for the development of his personal sculptural style. "I started transferring my collages onto a wooden surface to experience the hardness and the sheen of the various paints on the different kinds of paper. All of I sudden, I wondered what it would look like as a sculpture if I joined several painted boards together. I first painted the surfaces of the wood, then glued rice and pastel paper on top, and painted fragmented symbols. Suddenly, it was more than a painting stuck on a pedestal, because in a way the pedestal sanctified it. It was three-dimensional, and yet, at the same time, it seemed to capture the lyrical, engaging, and eternal feel of pastel."

Naminggha decided to push sculptural volume and power further by creating an upright three-dimensional wooden piece. He did so in *Cloud Image*. "Here I transferred my collages on paper to wood in a fully sculptural manner, while preserving the collage feeling and the materials of collage—acrylic, rice paper, and bark."

Yet wood, even with the addition of collage and painted, wasn't quite enough, for he became obsessed with achieving his all-important central passageway as a negative space. In a breakthrough in 1994 he conceived of *Kachina Symbolism II,* an eighteen-by-twelve-by-five-inch bronze. "I began with foam-core cutouts, assembling them and then using the negative space as part of the design element. I began to envision negative space as a

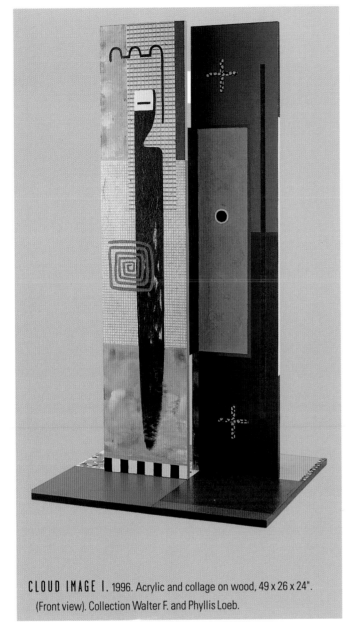

CLOUD IMAGE I. 1996. Acrylic and collage on wood, 49 x 26 x 24".
(Front view). Collection Walter F. and Phyllis Loeb.

much-needed counter balance to the solid forms."

The entire center of the work became a passage-way decorated with fragments of kachina faces — from top to bottom, the negative space on left side is the other half of the kachina with a small horizontal bar indicating an eye. That space balances the solid horizontal opening which is the kachina's other eye. Below the face, the vertical lines with negative and positive forms and spaces stands for falling rain. There are two other fragmented kachina images at the bottom. The artist achieved the desired patina by torching various chemicals to the bronze surface — the colors depending on which chemicals he chooses.

In *Kachina Symbolism* of 1996-97, another change in the artist's stylistic development of sculpture took place. In a real sense it is the culmination of his career-long struggle to capture realism within minimalism. Subject matter has become secondary, and pure form is dominant.

Today in his sculptures the voids, those all-important negative spaces, are frequently more expressive than the solids. And the patinas that he covers his bronzes with, which evoke clouds and the kind of infinite space seen only in the recesses of the mind, are as splendidly crafted as the borders of a princely commissioned late Medieval Book of Hours.

Dan Namingha has succeeded in bridging the gap between night and day, past and future, then and now.

Gallery

DESCENDING SPIRITS. 1972. Oil pastel on paper, 21 x 8". Private collection.

This work was done when the artist was twenty-two years old, and is the successful culmination of a series of experiments with the subject matter of fragmented kachinas and the free-flowing application of color. Three fragmentary and overlapping kachina faces are vertically linked in order to capture a feeling of descending spirits. "I made the lines continuous so that the contours of one kachina move to another in a single movement and one image seems to create another. The cube-shaped eyes in the center, for example, give birth to the image below."

To achieve the desired softness of colors, the artist first rubbed a cloth soaked with turpentine onto the surface of the Bristol paper. Then, while the paper was damp, he worked various oil pastels into it with another cloth. "I wanted to contrast the soft pink and blue tones of the kachinas with the rust-terra-cotta background to make the images stand out and also to make all elements harmonious, which is the spirit of kachinas."

Kachinas are vital to Namingha's art. He was tremendously impressed when he encountered them in a ceremonial dance for the first time when he was seven or eight years old. "As a kid I was mesmerized by their appearance. My grandfather explained that they were spirit messengers, representing goodness, clouds for moisture, and a blessing for the people. He told me that there are over one hundred different kinds of kachinas, each representing something important in our lives, such as rain, snow, plant life, and animals."

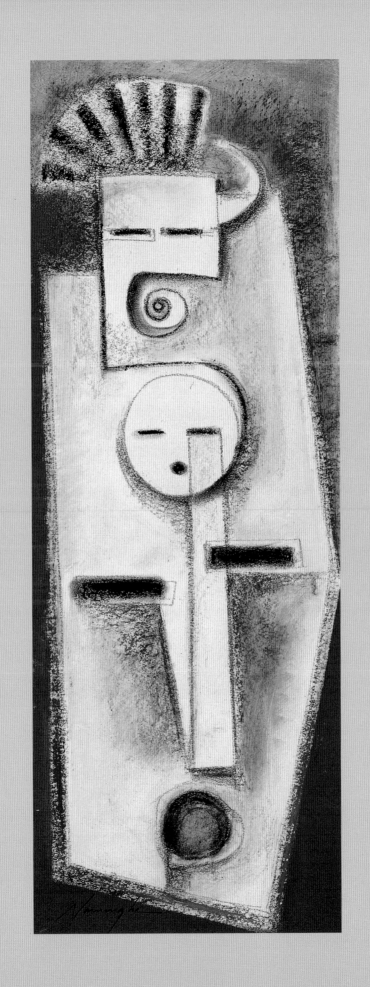

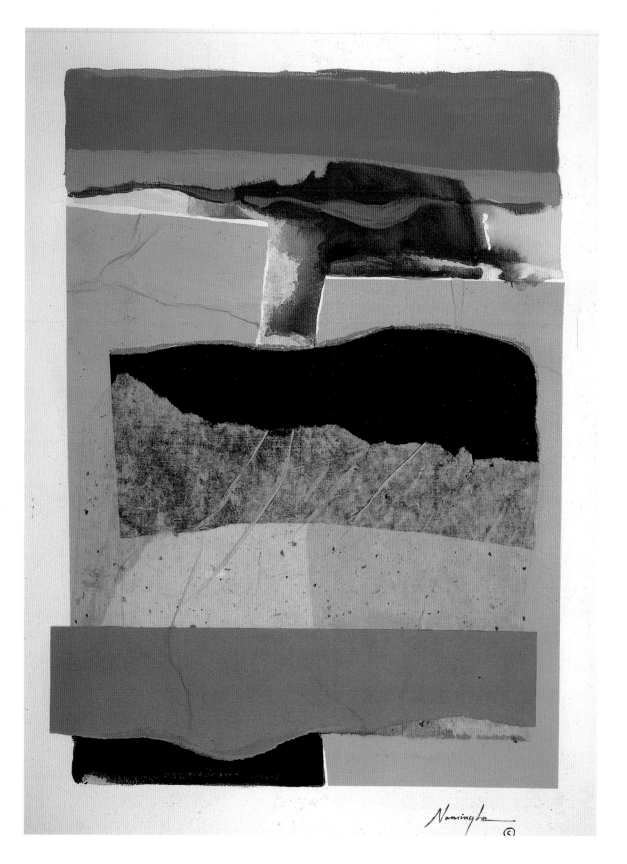

CANYON. 1978. Mixed media on paper, 30 x 22". Private collection.

The work represents a terra-cotta–colored mesa, no doubt a reminiscence of Hekytwi, the sacred Badger clan site, against an azure sky with a small canyon and desert landscape in the foreground. This was one of the artist's earliest experiments in refining realism into minimalism. Poetically, the process resembles the way the earth was formed. The artist took a sheet of watercolor paper, placed it on a board, and over time built up a variety of papers—tissue, pastel-tinted art paper, newsprint, and semitransparent rice paper—one on top of another, laying them in, building them up. He'd tear up the papers and move them around until he got the combinations that pleased him. He would then paint over them and begin again tearing up and applying more papers until the multilayered earth formations developed. To every level of this thickening surface, he applied flat acrylic colors and washes. He wanted a host of forms and textures to be seen through each other so that, in a sense, one landscape would create another. "Why black in the center? Everything was so earthy-toned I wanted to break it up. Besides, sometimes in the desert you'll see a very stark rock formation that will stand out from the rest of the landscape like this."

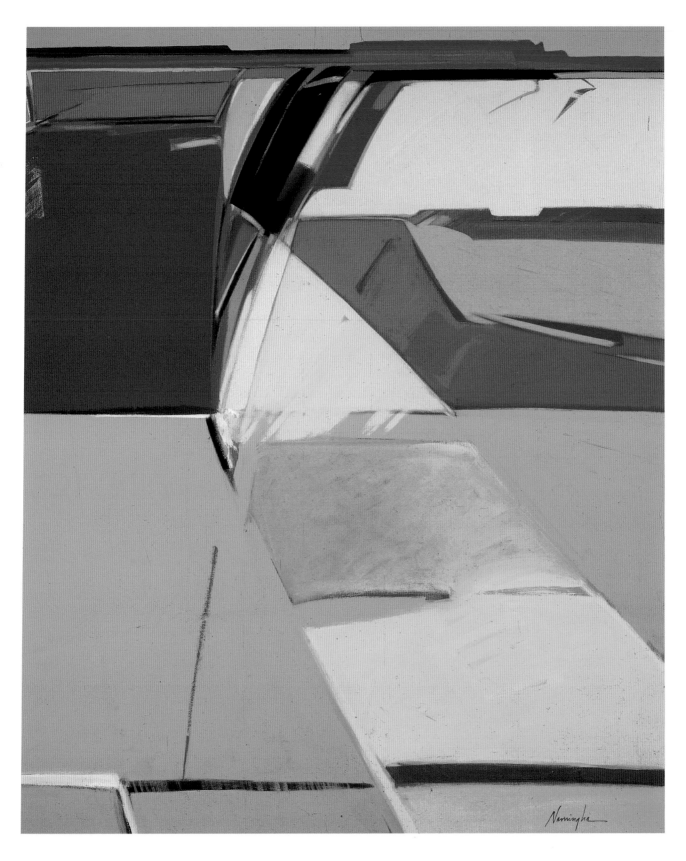

RESERVATION VIEW. 1980. Acrylic on canvas, 72 x 60". Private collection.

The idea for this monumental landscape, in which the mesa appears as a blunt terra-cotta plateau in the far, far distance, came to the artist when he was driving his truck through the Hopi reservation. Looking ahead, he would occasionally glance into the rearview mirror. He became entranced by this double vision, for this synoptic view created a split image of the sere landscape appearing both in front of and behind him. One can easily recognize the arroyos and deep cuts and slashes in the rugged land. The dark areas and lines are meant to represent shadows created from the clouds. This landscape is the first of his fully mature depictions of the landscape of his birthplace.

SPRING STORM. 1984. Acrylic on canvas, 60 x 48". Collection the artist.

This luminous painting presents the mesa silhouetted against a brilliant sunset sky after a storm has blown through. The sharp pinks, blues, and reds in the foreground symbolize the shining textures of the usually monochromatic desert, which are always surprisingly rich in color after being drenched with rain.

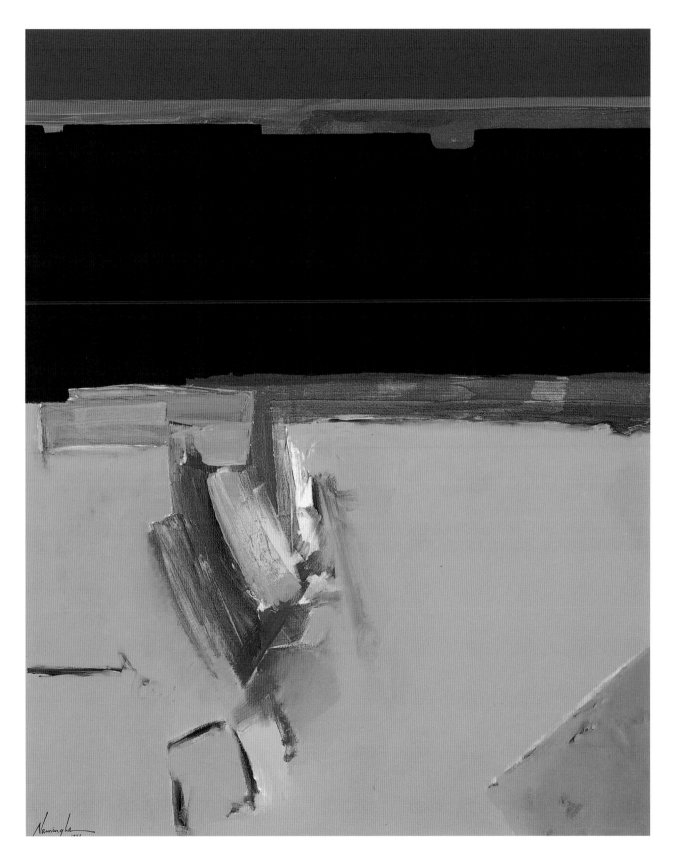

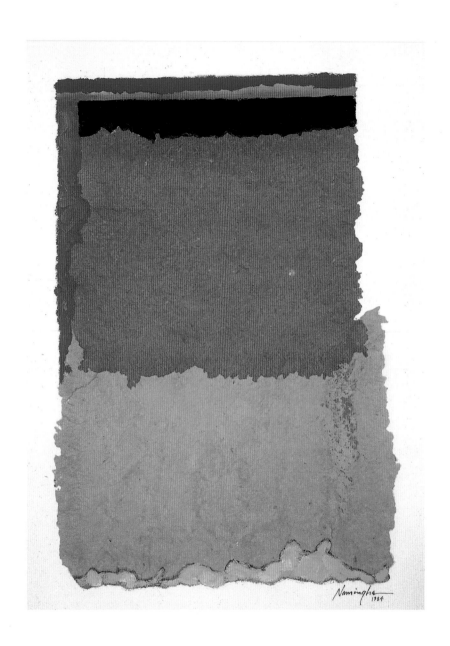

NEW MEXICO DUSK. 1984. Collage on paper, 30 x 20". Collection Robert Redford.
The artist made the papers for this collage himself, and, when he had assembled
them, the textures reminded him of a landscape. He then painted with acrylics to
render an impression of a sunset.

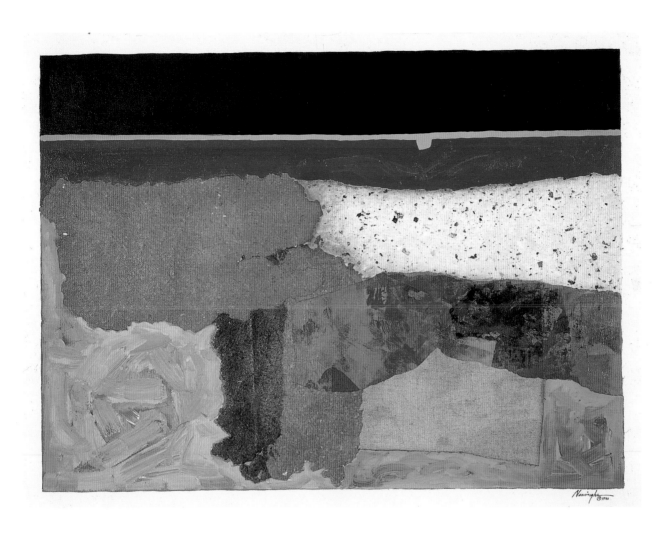

VIEW OF FIRST MESA. 1986. Collage of handmade paper, 20 x 30". Private collection.
Here, again, the textures of the handmade paper suggested a landscape, and the
artist applied acrylic paint to the areas that would transform the paper into First
Mesa, the distinctive one with the gap almost in the middle. The moment captured
is when the very last rays of light linger before the lavender-blackness of night
descends.

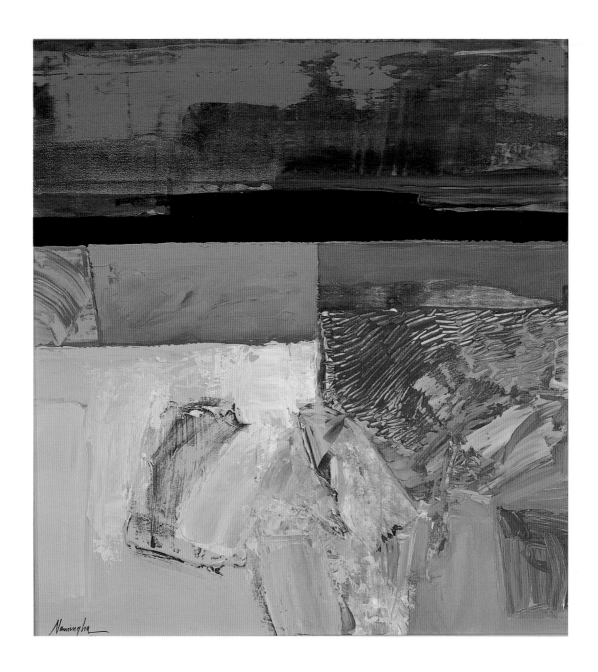

RAIN SKY. 1987. Acrylic on canvas, 32 x 30". Collection Philip and Wendy Kistler.
"In the upper part of this painting, I applied thick paint, and then scraped it so that I created the impression of a sunset at the moment rain clouds were disappearing. To evoke the vivid textures of the land I loaded on paint again, scraping into it to create those startling colors and shapes. I got the idea from the handmade paper I was working with at the time. Just translated it into acrylic."

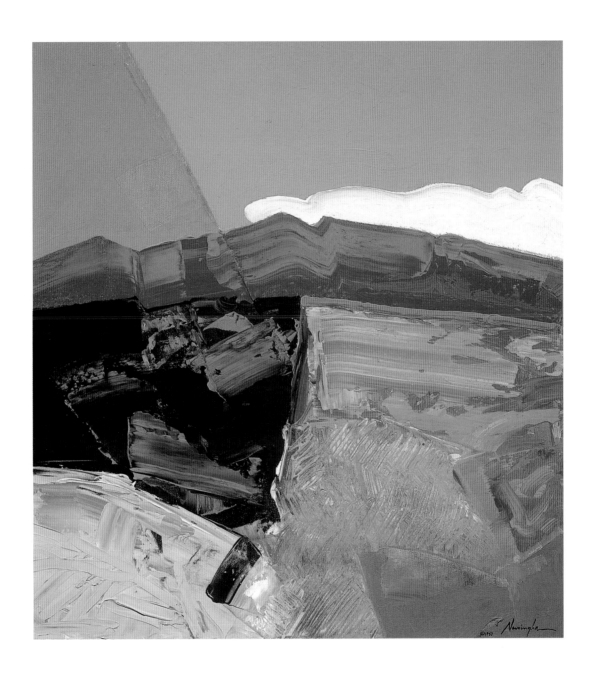

STUDIO VIEW #2. 1987. Acrylic on canvas, 30 x 28". Private collection.
This small, intense picture is the artist's impression from his studio of the soaring
Sangre de Cristo Mountains in summer. "I became fascinated with applying thick
paint and scraping into it with my brush handle and palette knife in order to get the
feeling of the textures of the land. Here, I began to think the color of the sky was
too even, so I broke up the blue with a darker tone on the upper left. Afterward,
seeing that that particular emphasis needed a counterbalance, I painted in a grayish
color at the lower right of the landscape. The center bridge line that doesn't quite
connect lends the correct amount of tension to the scene."

RESERVATION LANDSCAPE #2. 1989. Mixed media on board, 15 x 40".
Collection Museum of Fine Arts, Santa Fe, New Mexico.
In the 1980s the artist started painting horizontal landscapes. In this one, in which
the feeling of the mesa is overpowering, he used wood bark, rice paper, and acrylic,
attempting to build a reflection of the unusual textures of the land.

HEKYTWI VIEW #1. 1992. Mixed media on board, 15 x 40". Private collection.

"With this impression of the Hekytwi Mesa, I incorporated wood bark and layers of very thick paint, which I then dug and scratched into to create texture. Living in two cultures as I do, I'm always conscious of the dual nature of all things. To express the duality of the approaching storm—first a calmness, followed by thunder and lightning—I split the painting and the mesa in half with two different shades of color. The left half is brilliant, indicating the sunlight hitting the land; the darker color stands for the approaching storm."

HEKYTWI VIEW #3. 1992. Mixed media on board, 40 x 30". Private collection.
For this powerful image of the mesa that crowns a rich and subtle landscape, the artist first applied real sand to the board to pick up the exact color of the land. The shapes and colors in the foreground are shrubs, patches of rabbit brush, and some snake weed, all of which grow at Hopi. The paint was applied thickly in several layers, which the artist then scraped to give the impression of dry shrubs leaning in the direction of the prevailing winds.

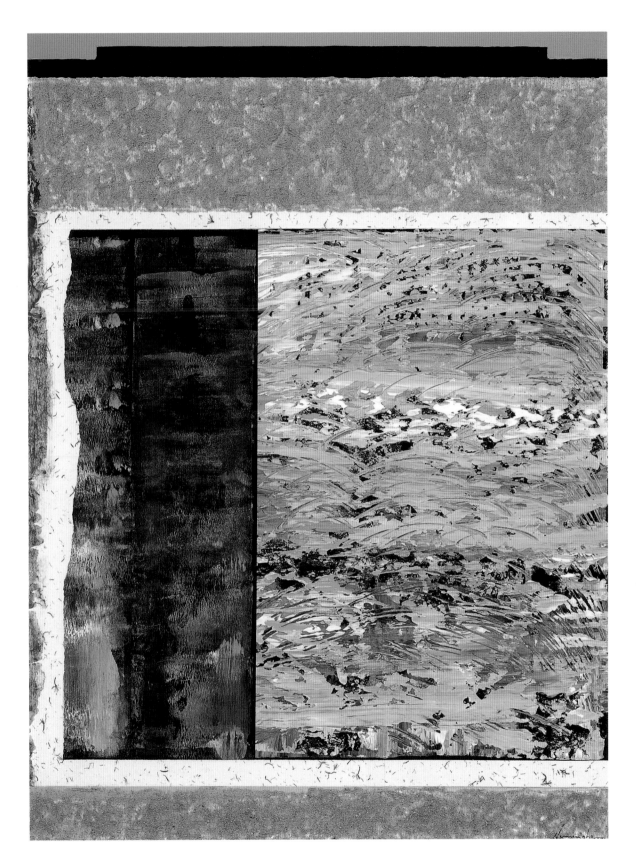

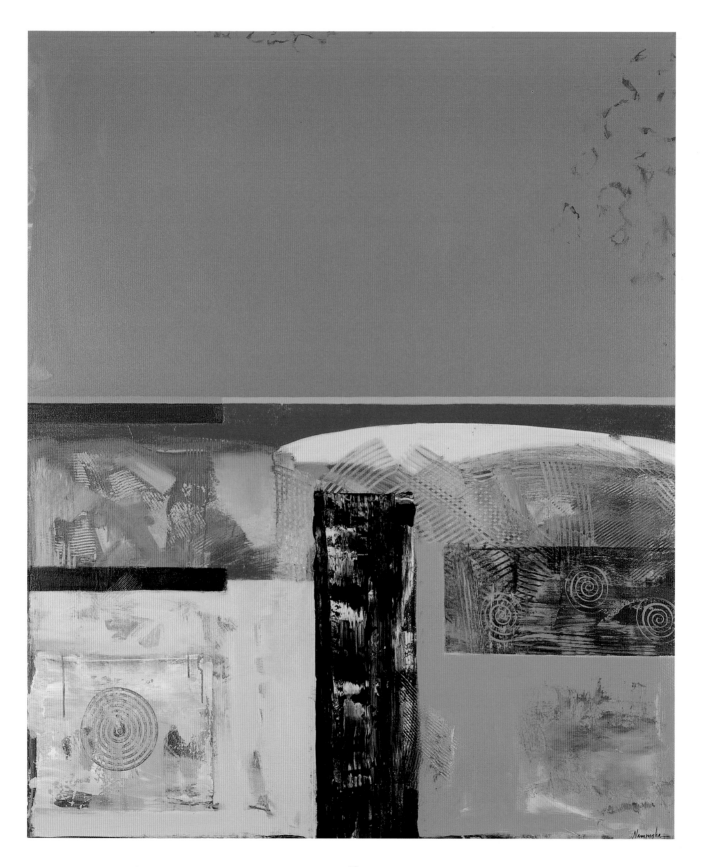

EXCAVATION #1. 1993. Acrylic on canvas, 72 x 60". Collection the artist.

The broad blue sky looms over the mesa. The foreground contains abstract elements that look somewhat similar to the kachina fragments in *Descending Spirits,* painted some twenty years earlier (page 47). The black shapes and the scratches also refer to archaeological sites. "The scratches signify illegal diggings, some of them made by treasure hunters just hammering away with bulldozers. These are unthinking, aggressive diggers looking for the quick hit, not for historical data. They have no sensitivity toward a culture. We call them bulldozer archaeologists. They want to find any trophy, and in the process desecrate what is sacred to another culture. This painting has in it my feelings about the insensitivity and greed of certain men."

The faint spirals indicate the birth and evolution of the ancient people that existed here at one time, and moved on to continue their migration. The people of the Hopi and Pueblo cultures return annually to these sites to pay homage to their ancestors.

HEKYTWI MESA. 1994. Mixed media on canvas, 72 x 72". Private collection.
The upper part of the painting represents the lifting of black rain clouds and blue
sky emerging over the horizon. The bottom half of the painting relates to the artist's
fascination with the dualities that exist in all cultures. The deep magenta on the
left of the mesa evokes the light reflecting off the richly colored surface of the rock.
Namingha separated the blocks of textures to suggest the varied land textures of
the Hopi reservation.

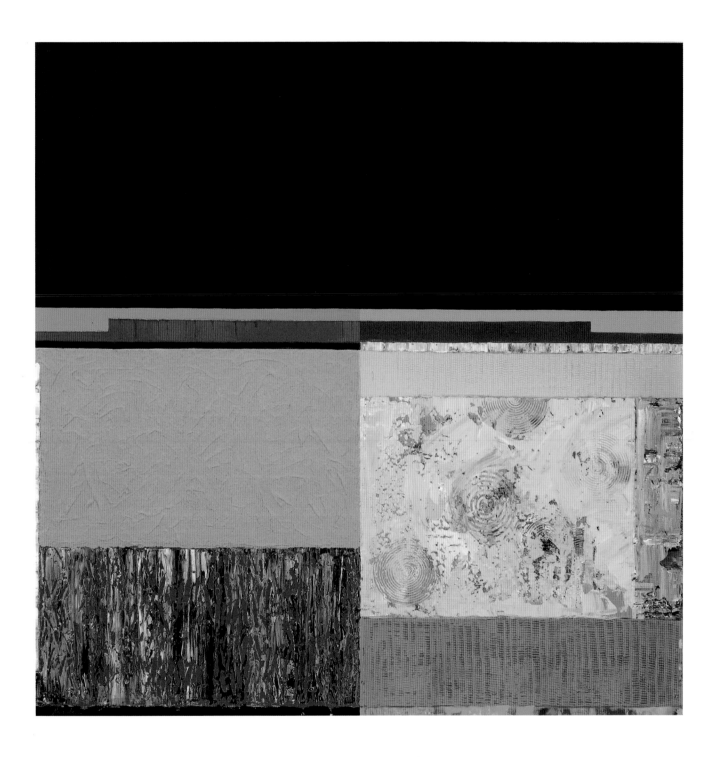

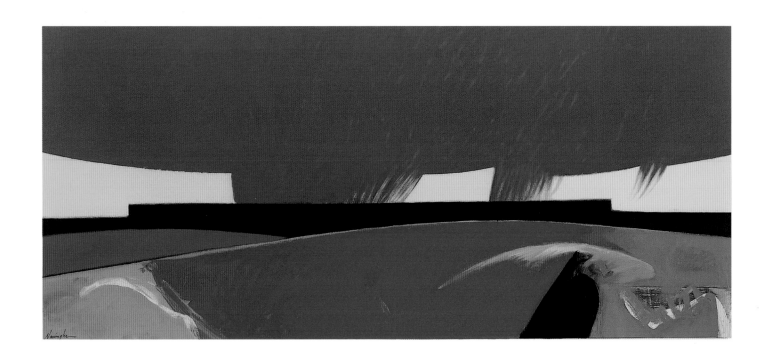

STORM AT DUSK. 1994. Acrylic on canvas, 32 x 72". Collection the artist.

"I sometimes return to representational painting because, for me, realism is the foundation for abstraction. Here, I wanted to add a different life and feeling to the rainstorm over the mesa, making it a more gentle and benevolent storm."

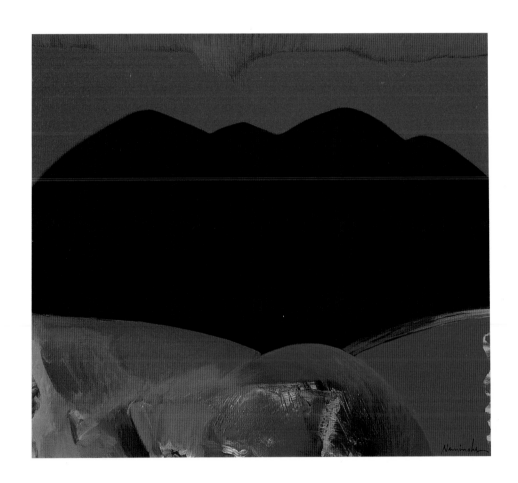

STUDIO VIEW OF THE JEMEZ. 1995. Acrylic on canvas, 32 x 36".
Collection A. M. and Paul Abbott.
"This painting represents the Jemez Mountain range in New Mexico, looking west from my back patio. Sometimes the sunsets are very intense and the hot red I used indicates that intensity. The mountain range is silhouetted by the brilliant red sky."

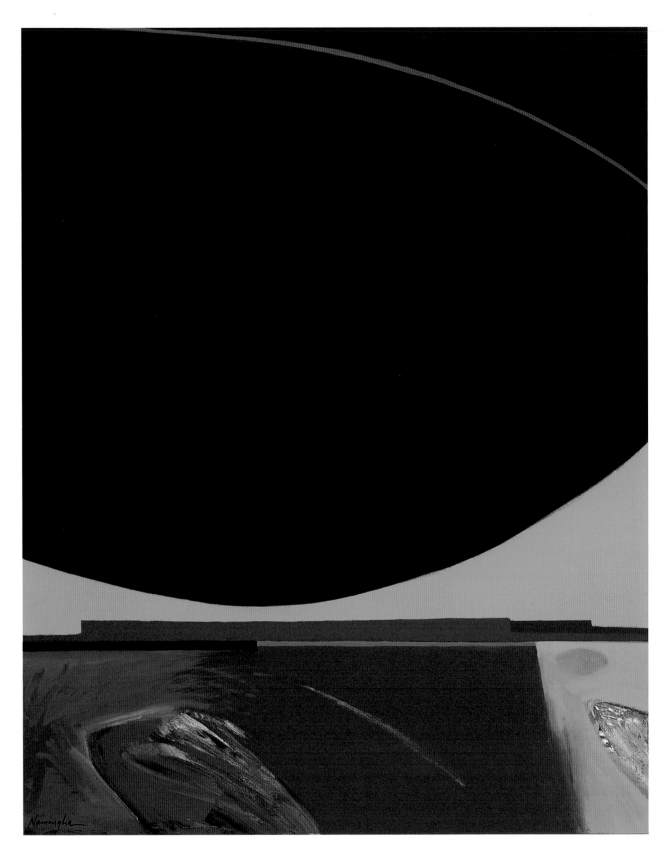

HOPI SERIES # 1. 1995. Acrylic on canvas, 50 x 40". Private collection.

The artist uses colors not only to create naturalistic elements but also to fashion a special visual poetry. The red line represents a sudden break in a black storm cloud that is rapidly moving away. That slight red break in the darkness makes the landscape shimmer. For the artist, the curves are both purely formal elements and symbols of the gentle rain.

LA TIERRA XI. 1998. Oil pastel on paper, 23 x 29". Private collection.
This work grew out of pen and ink drawings in the artist's sketchbook. He added
color to indicate hills and to reflect the immediate surroundings of his home-studio
outside Santa Fe in an area called La Tierra, the Spanish word for earth.

LA TIERRA XIII. 1999. Pastel on paper, 23 x 29". Collection the artist.
Here, the artist experimented with brighter colors because of the specific atmospheric conditions of the day on which the work was created.

WEST OF KYKOTSMOVI. 1996. Acrylic on canvas, 30 x 120". Collection Mr. and
Mrs. William Freeman.
This view reveals an imposing mesa near the Hopi village of Kykotsmovi and a
piece of the desert that stretches eighty-five miles between the village and
Flagstaff, Arizona. The artist recalls driving the road a number of times, especially
during the summer, when this particular mesa range is stunning. For the panoramic
view he used an extremely long, horizontal canvas. The large oval shapes represent
sand dunes, which are rare in the Arizona and New Mexico deserts.

opposite:
HORIZON #1. 1996. Acrylic on canvas, 84 x 20". Collection Elizabeth A. Sackler.
"The idea for this skinny vertical landscape came to me one day when I happened
to look through the slightly opened door to my house. The light was streaming in,
partially distorting the landscape. I had the urge to depict the fragmented landscape
in a cylindrical way to capture that feeling. The white dots on the right side are
pieces of torn paper pasted to the canvas, which I then painted white."

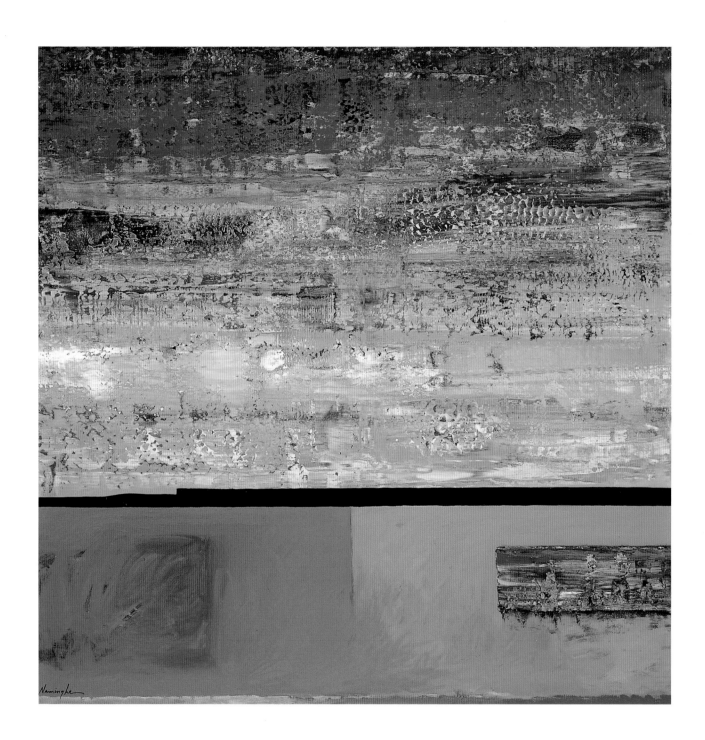

ANTELOPE MESA. 1994. Acrylic on canvas, 48 x 48". Collection Dr. and Mrs. Robert Bell. The artist calls this lyrical landscape "God's fireworks display," and explains that it represents a brilliant sunset over the Antelope Mesa range at Hopi, which is silhouetted in black. He worked the heavily layered paint for texture using tools—trowels and floaters—that are normally used to smooth newly plastered walls. The paint was allowed to dry, then scraped; more paint was applied on top, and then the surface was scraped again, a process repeated several times.

HOPI SERIES #2. 1995. Acrylic on canvas and mixed media. 50 x 40".
Collection Jay Geller.
For the artist this is a very successful coming together of realism and minimalism.
"The upper part of the painting depicts a sunset. I put sand into this painting, then
painted it black just to impart the feeling of a true desert. That grayish horizontal
line in the middle is a purely formal element I used to break up the solid black color.
At the bottom of the painting you'll recognize a series of gashes. Those are what
you see on the desert floor or on the side of a mesa cliff. I wanted an element of
surprise in the smooth flat color."

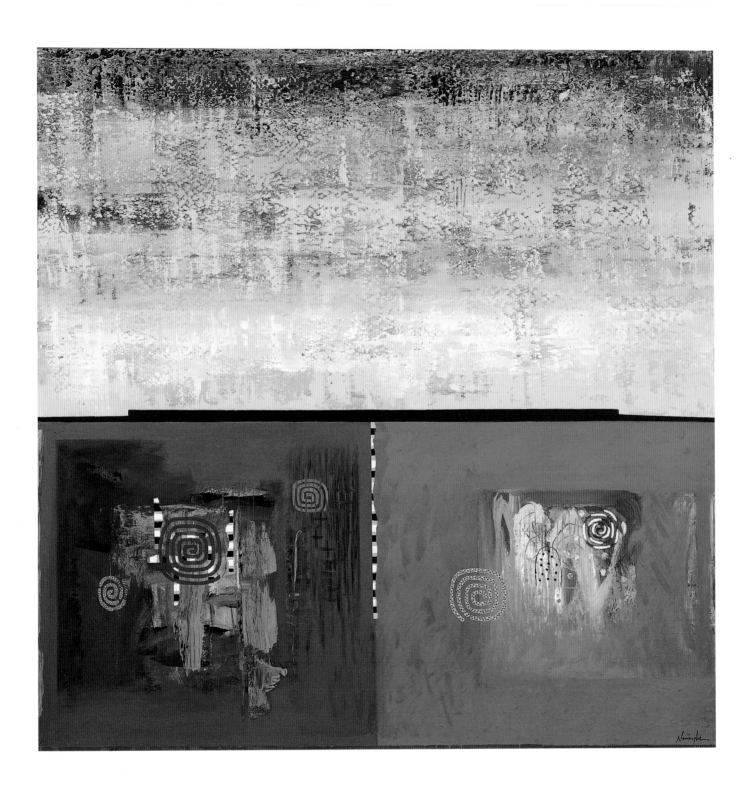

HEKYTWI SUNRISE. 1996. Mixed media on canvas, 80 x 80". Private collection. Namingha made the mesa long and skinny to give the impression of looking at it through a wide-angled lens. He applied many layers of paint in the sky to capture the feeling of a hot summer morning and the presence of gentle rain forming mirages, or a distinctive kind of rain cloud in which the moisture hovers above the surface of the desert but never reaches the ground.

In the bottom half of the painting are fragments of the circular Hopi migration symbol. The half circle with black dots in the center in the lower right represents a corn plant, and the black and white line in the center evokes the Hopi symbol for rain.

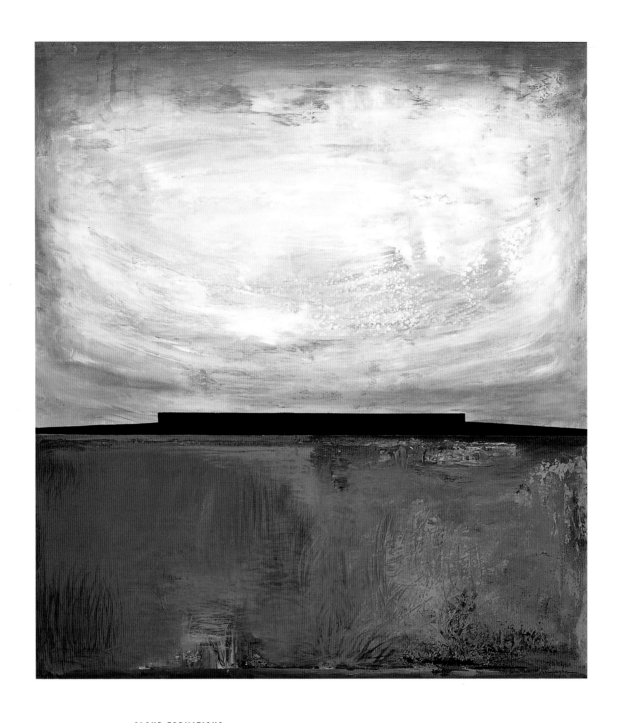

CLOUD FORMATIONS. 1999. Acrylic on canvas, 44 x 40". Collection the artist.

In 1999 the artist created a series of forty landscapes, each employing the same nearly square shape, and each featuring a black mesa close to the center of the canvas. "I made them to concentrate on the sky and I overlapped paint in many layers and then worked on the textures with trowel, floater, and pallet knife to get those interesting cumulus clouds."

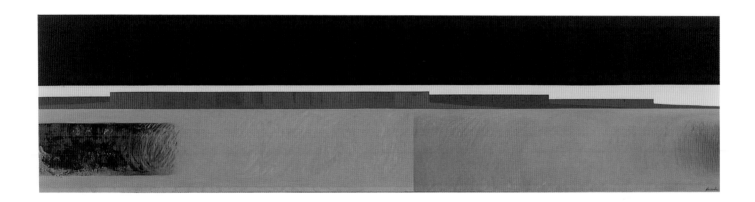

SOUTHWEST LIGHT. 1999. Acrylic on canvas, 30 x 120". Collection Norman and
Donna Harbert.
This large panoramic view of the Hopi desert landscape contrasts the grays of the
desert with the darkening twilight sky over the mesa in a real and abstract manner.

THE PUEBLO SERIES

There are numerous archeological sites throughout the southwest once inhabited by the ancestors of the Hopi and Pueblo culture, known as the Anasazi. These sites date back thousands of years and are located in New Mexico, Arizona, Colorado, and Utah. The following five paintings explore the shapes and spirit of some of these places, many of which have been continuously occupied. Pueblo is the word the Spaniards used to describe the sandstone or adobe architecture. Today these sites are occupied by different Pueblo tribes in New Mexico and further west on the Hopi reservation in Arizona. "When I was very young, I tried to depict Pueblo villages at Hopi in crude child drawings. As I grew older I became fascinated with the design and architectural structure. By the mid-1970s, I began working on a series of paintings to capture the Pueblo structural and design framework. I used vertical and horizontal lines and varying shades of color to express the architectural feeling and flavor. This series is ongoing."

VILLAGE. 1980. Acrylic on canvas, 84 x 72". Private collection.
The artist calls this painting a portrait of a Pueblo village in which he particularly focused on purely formal characteristics and the complicated patterns of hard-edged vertical and horizontal lines.

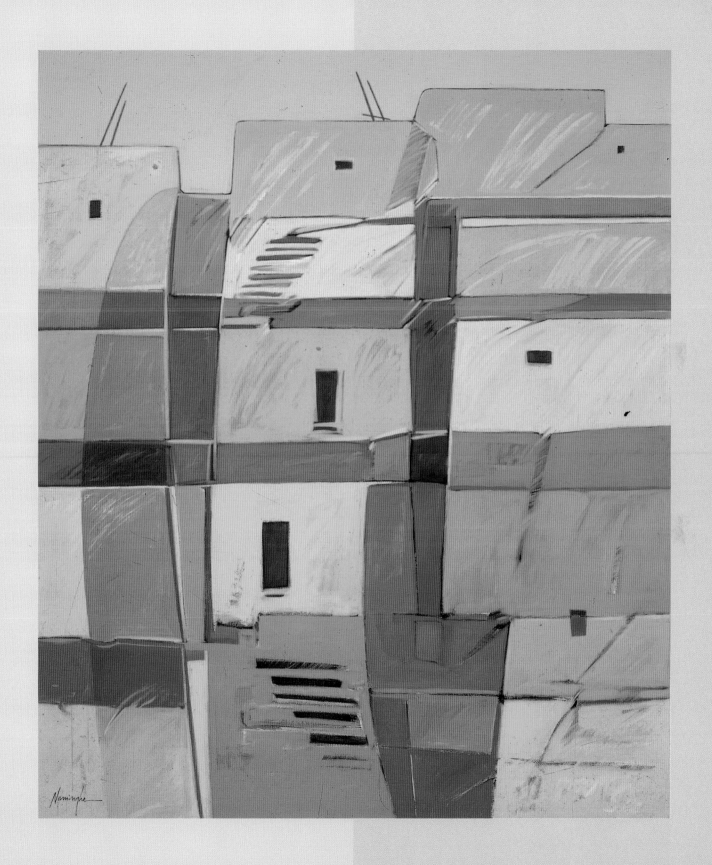

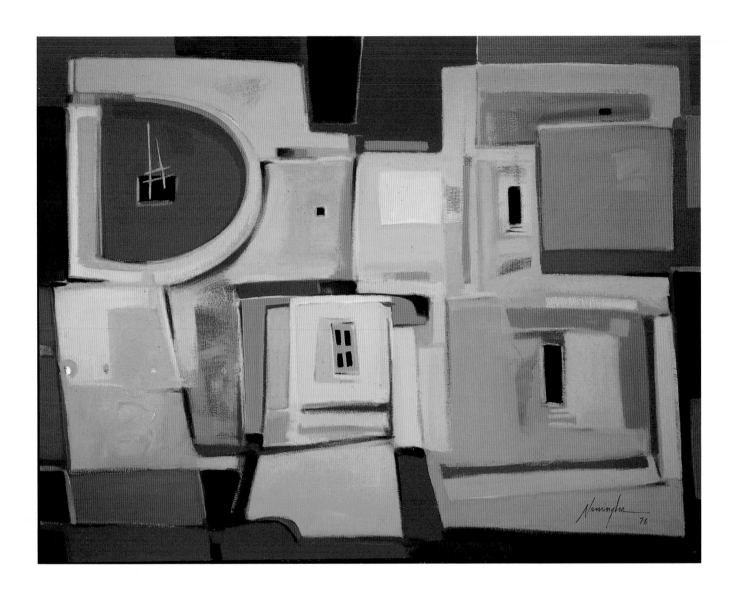

PUEBLO STRUCTURE. 1978. Acrylic on canvas, 35 x 50". Private collection.

A complex of pueblos is viewed simultaneously from ground level, from an aerial view, and from the side. The effect is similar to that of the artist's *Reservation View* (page 51), a split image achieved by his looking through the windshield of his truck and the rearview mirror at the same time, creating a synthesis. Here, the viewer sees doors, windows, walls and rooftops of the village pueblos as if they could all be seen from the same vantage point. A stepladder protruding from the rust-brown opening on the upper left represents the entrance to a ceremonial chamber, called a kiva.

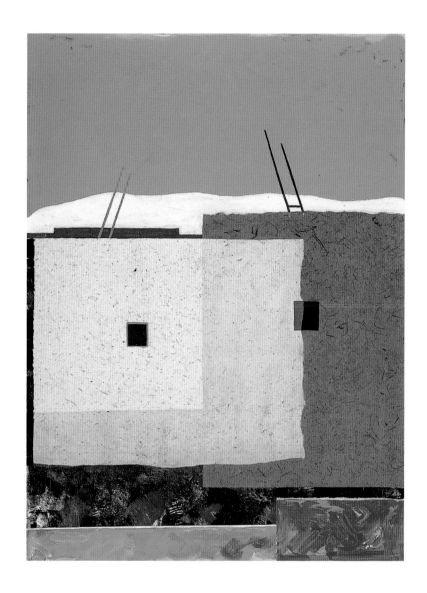

DISTANT CLOUD. 1990. Mixed media on board. 40 x 30". Private collection.

Here, the familiar wooden ladders of Pueblo architecture rise up from the rooftops as a distant cloud emerges from behind the village. "I used two different types of rice paper as a base because they related perfectly to the texture on the walls of the Pueblo village. Acrylic paint completed the composition."

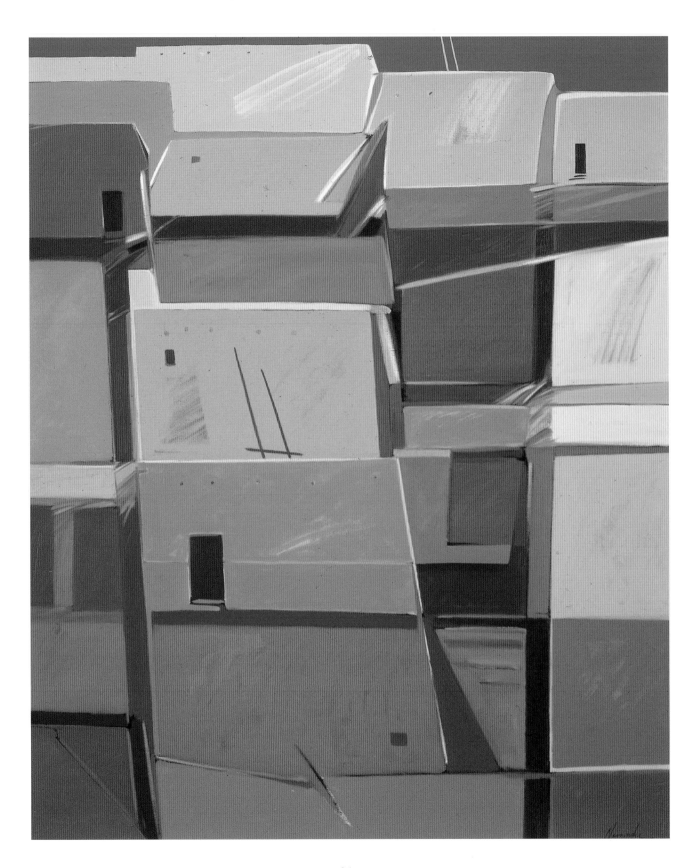

PUEBLO REFLECTIONS. 1981. Acrylic on canvas, 84 x72". Private collection.
This painting offers the same conception as that in the work reproduced on page 83, but here the slender ladder shapes become delicate accents in the overall abstraction.

HOPI DWELLING. 1990. Acrylic on canvas, 60 x 60". Private collection.

As the artist progressed with the Pueblo series, certain colors that had appeared in his landscapes began to show up because they reminded him of the plastered walls of dwellings. This work represents a village like Walpi, which is built on top of the mesa and close to the edge.

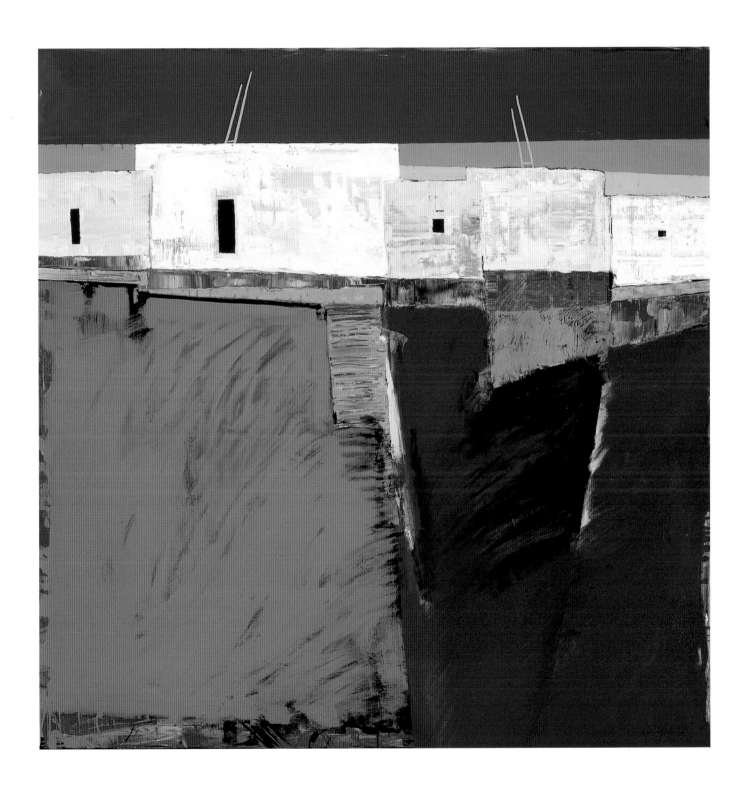

KACHINA IMPRESSIONS

The following series of eleven works refer to aspects of the Hopi kachina spirituality. Namingha continues to create kachina paintings today.

"My grandfather introduced me to ceremonies when I was a boy. The ones that left a lasting impression on me were the kachina ceremonies, which are held during the winter and summer months. In the winter the rituals take place inside the ceremonial chambers called kivas. When we had severe snow storms at Hopi, the road leading up to First Mesa would often be closed. On those occasions my grandfather and I would hike up the mesa to the ceremony in the storm. Once, it was late in the evening as we walked up through a foot of snow. When we arrived at the kiva we climbed down a stepladder through an opening in the roof and down into the warmth of the kiva. We waited patiently with others for the kachinas to appear. When they arrived at the top of the stepladder, an elderly man seated below asked them in the Hopi language to enter. The kachinas began their descent one by one down the ladder and formed a half circle in the center of the kiva. They began chanting and dancing. This went on until early morning, as different groups of kachinas made their appearances. Before the kachinas left the kiva, they gave my grandfather and me gifts of dried fruit and a bundle of fresh baked sweet corn tied together. My grandfather explained that a kachina's gift is a gesture of friendship and ensures that you will be blessed with good health. When the ceremonies were over, we left the kiva and began our descent down the mesa, trudging through deep snow to my grandfather's house in the crisp early light. That was the best experience of all."

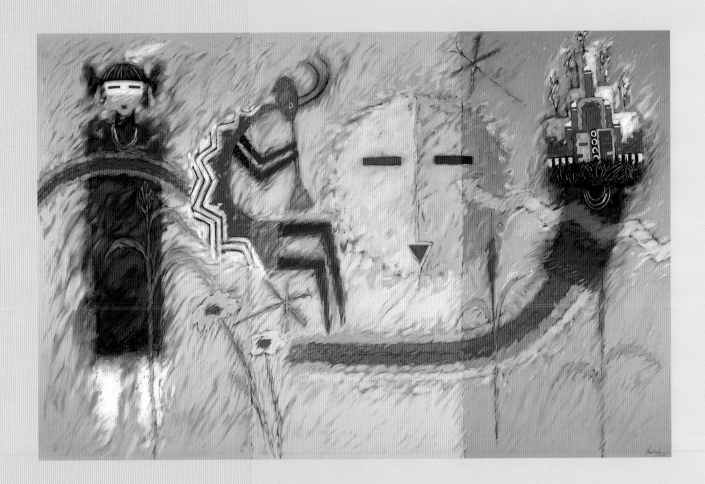

NIMAN BLESSING. 1986. Acrylic on canvas 80 x 120". Collection Sundance Institute.

When the artist began working on the painting, he sketched in all the images from left to right, beginning with the rainbow, then adding a young maiden with a corn plant before her, and then the humpback flute player known as Kokopeli, who symbolizes fertility and germination. This was followed by Dawa, the sun symbol, and, finally, the Niman kachina, which appears at the last kachina ceremony in mid-July. The appearance of the Niman kachina signals the time when all kachinas return to their home in the mountains until they reappear again in February.

Elements of summer appear throughout the painting, as well as indications of bountiful rain: the headdress of the Niman kachina with a variety of rain symbols, clouds, and a zigzag image expressing a lightning bolt. Rain, of course, is essential for the Hopi because it brings a bountiful harvest and good health to the people. Also included are flowers, cattails, and dragonflies, which are present at sacred springs. The background, which is divided into three parts by beige, gray, and blue, represents the physical world, the intermediary, and the spiritual world. The brushwork was inspired by a Monet painting of water lilies that the artist saw as a young man at the Art Institute of Chicago. Here he was seeking, as he says, "an impression of movement and an explosion of energy expressed in the surging current of paint."

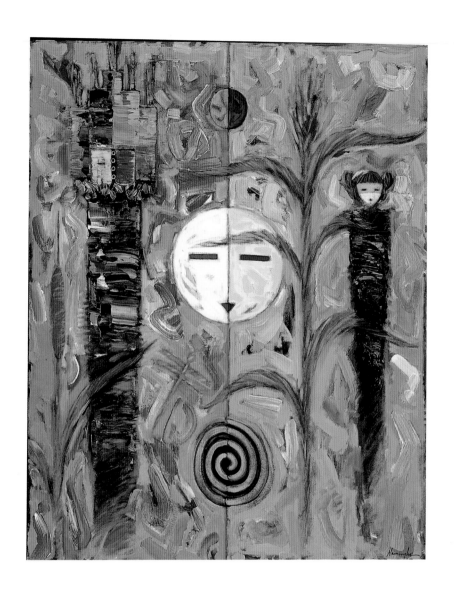

HARVEST CHANT. 1991. Acrylic on canvas, 50 x 40". Collection Ira and Mara Friedman. This painting was inspired by *Niman Blessing*, but is more painterly, with added textures. The sun symbol dominates the center. Above it appears a blue image of the moon, divided into two parts for night and day. At the bottom is the circular symbol known as Sipapu, which represents the migration of the peoples, as well as the center of the world from where the Hopi emerged. On the left is a figure of the Niman kachina and on the right is a corn plant and an image of a kachina maiden. The artist has divided the work down the center with a thin line and two subtle colors to indicate the physical and spiritual worlds.

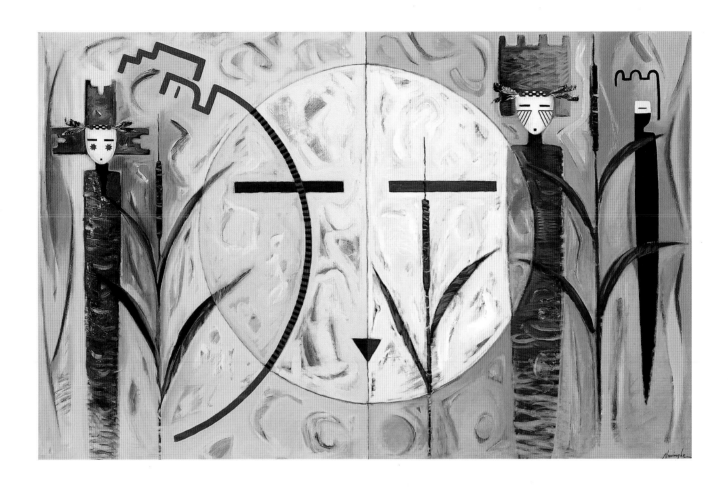

ELEMENTS OF SUMMER. 1995. Acrylic on canvas, 48 x 76". Collection
Mrs. Virginia V. Mattern.

From left to right, the artist has depicted in different styles four maidens such as
those who dance in the summertime Butterfly Ceremony. The second image has
been rendered with a simple curved contour line so that the figure will be appropri-
ately minimized to contrast with the others, which are fuller. The fourth maiden
appears as a partial image incorporating the wavy contour line for the headdress.
The symbol of the sun dominates the center of the work, and the cattails signify a
sacred spring. The bilateral form of the painting represent the artist's interest in the
dual existence of the spiritual and physical worlds.

HESOT DOLL SERIES #1. 1990. Acrylic on canvas, 50 x 40". Private collection.

"*Hesot* is a Hopi word meaning something of the far distant past. This painting represents a very old wooden kachina doll. I've seen similar ones in private collections or museums. The paint has peeled off so much that the kachina can't be identified. I find a sense of strength and mystery in these old carvings. I used thick paint and scratched into it to indicate the withered, worn quality of the wood with the paint peeling off a weathered doll that has survived time. My aim was to give it life by using vivid colors: they symbolize strength."

HESOT DOLL SERIES #4. 1990. Acrylic on canvas, 50 x 40". Private collection.
The concept and treatment is the same as in the painting on page 95. The kachina doll is weathered and worn but nevertheless still full of mystery and strength.

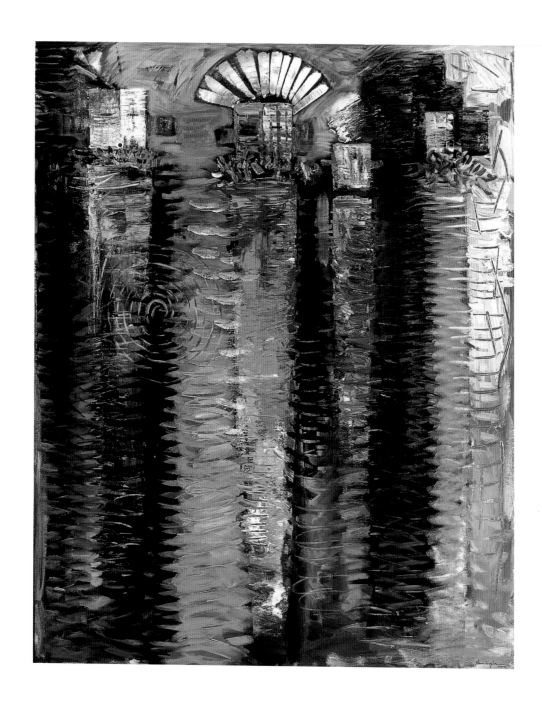

PUEBLO KACHINA IMAGES. 1991. Acrylic on canvas, 50 x 40".
Collection Helen E. Bock.
The artist was striving to capture the feeling of someone in a dream by suspending
the images and making them float back and forth. The headdress of the second
kachina is made of feathers.

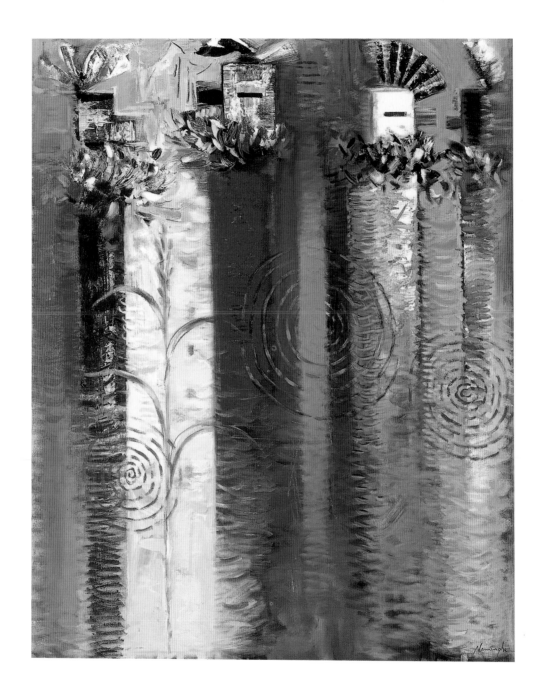

EMERGING KACHINUM. 1992 Acrylic on canvas, 50 x 40". Collection Greyson Bryan and Nancy Landon.

This painting expresses the same feeling as the work opposite. Here, the vibrant blue light in the center represents the light of mystery. The artist has shown the kachinas (known as Kachinum for plural in the Hopi language) only partially to achieve a dreamlike effect.

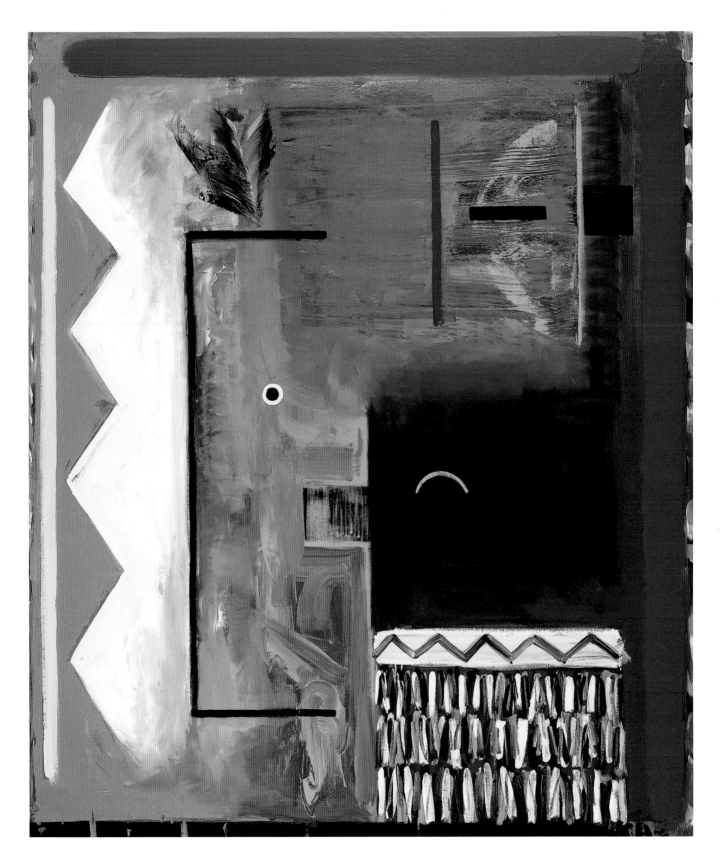

KACHINA SYMBOLISM. 1992. Acrylic on canvas, 84 x 72". Collection Stanley and Johanna Grabias.

The abstract composition depicts fragments of kachina faces and images: the white circle is the eye of a kachina; the vertical red line represents the central part of the head of another kachina. On the left is a bold lightning symbol. The blocks of color formed by paint scraped away are pure design elements. On both sides of the painting are raw undercolors that the artist decided to leave uncovered to add further strength to the design.

NEW MEXICO PUEBLO EAGLE DANCER. 1997. Acrylic on canvas,
72 x 60". Collection Michaela Graeb-Kieves.
This is not a kachina but an abstract concept of a Pueblo Eagle Dancer. The eagle's
name is Kwahu. It is part of another extensive series the artist calls his Bird series.
He was seeking action and rhythm, and chose strong colors for emotional impact.
The four lines serve as balances for the motion.

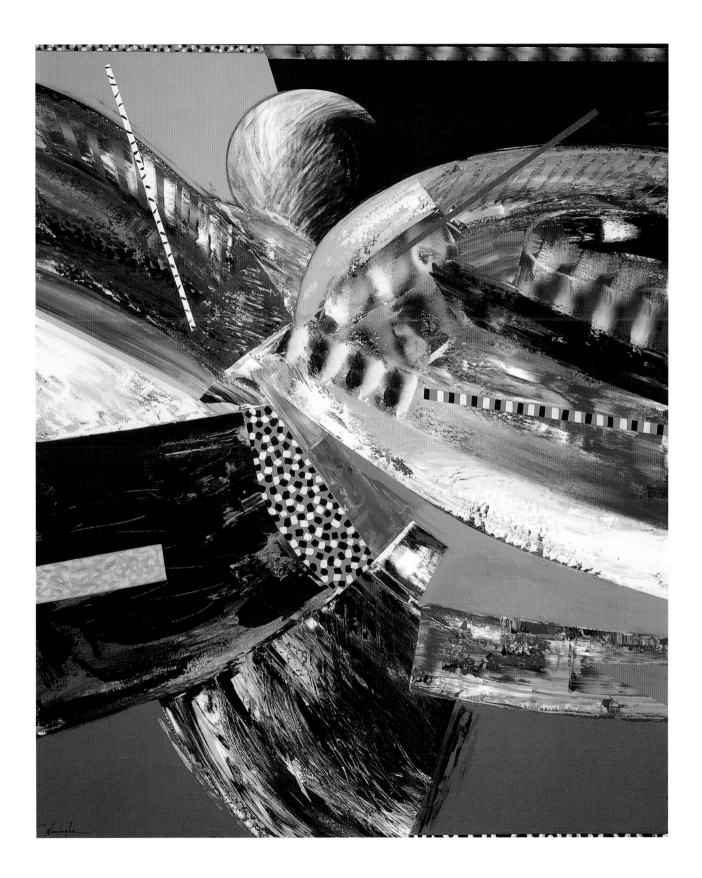

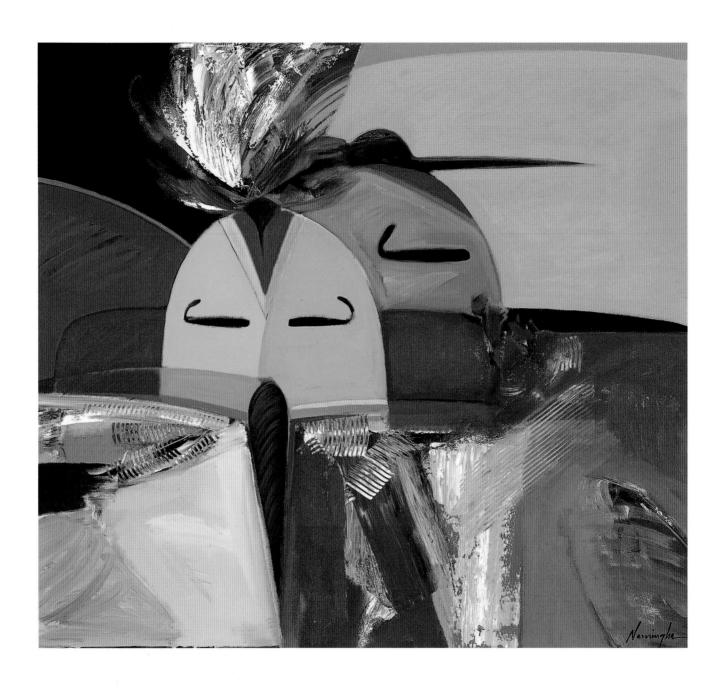

HUMMINGBIRD KACHINUM. 1995. Acrylic on canvas, 32 x 36". Private collection.

The style of this painting reflects some of the artist's early work from the 1970s. Here, only the heads and faces of the hummingbird kachina appear, as if the figure were merged into a landscape. The scraped areas of paint are rougher and more emphatic than what Namingha normally executes and represent a departure from his normal technique. He wanted to create a highly formal composition.

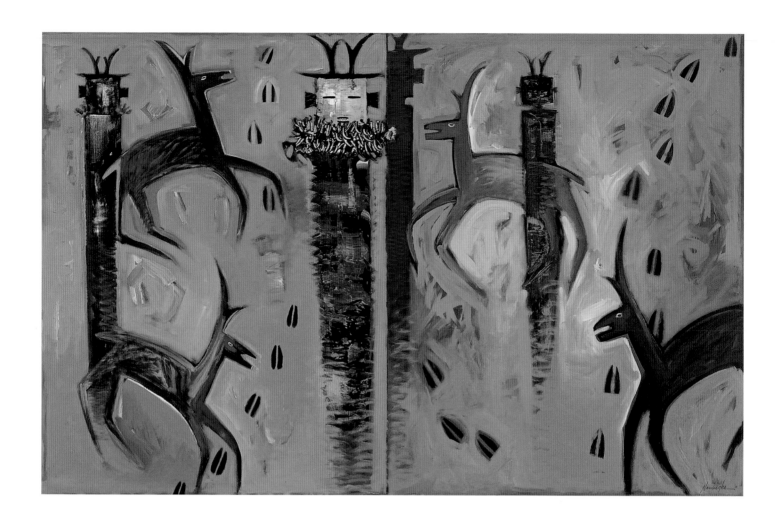

ANTELOPE MIGRATION SERIES. 1995. Acrylic on canvas, 48 x 76".
Collection John Quincy Adams.
The artist's idea was to portray the antelope during its seasonal migration, and at the same time to represent the kachina ceremony associated with the antelope. As he often does, Namingha divided the painting in half to suggest the change of seasons and also to symbolize the duality of the physical and spiritual worlds. The Hopi ceremony offers homage to the noble attributes of the antelopes so that they will flourish.

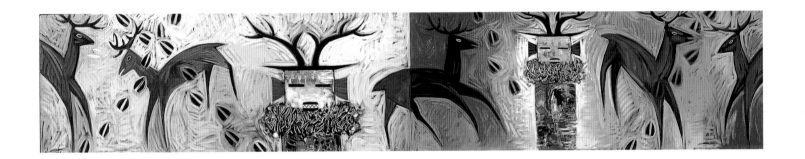

DEER MIGRATION SERIES, #1. 1997. Acrylic on canvas, 16 x 84".
Collection Michael and Linda Harrell.

The concept of this painting is the same as in the one opposite. The texture around the neck of the kachina, seen in two perspectives, represents mountain evergreen and stands for Nature. In finishing the painting, the artist applied the lighter areas last to have a light radiating behind the image for the greatest possible contrast.

Animal kachinas focus on the keen senses of the creatures, their eyesight, sense of smell and hearing, and their speed and courage. Deer are hunted by the Hopi, but before the beginning of any hunt rituals are performed so that the hunters may be guided to the game and be successful. Once a kill is made another ritual ensures the safe passage of the animal's spirit into the other world. The ceremony also aims to encourage more deer to flourish and bring rain. Here, there are two deer kachinas. The black dots are the deer hoof marks.

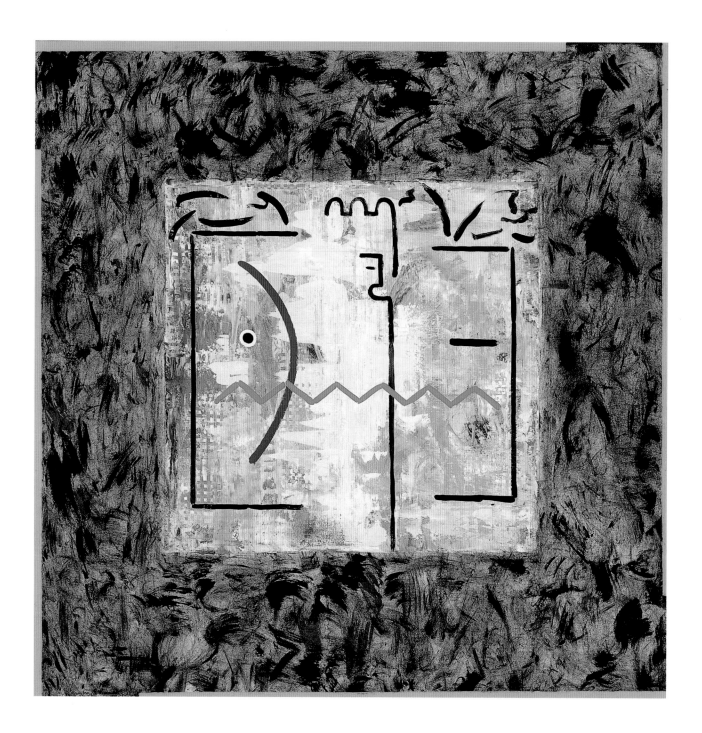

HOPI SYMBOLISM #13. 1993. Acrylic on canvas, 48 x 48". Collection Mr. and Mrs. Gregory Abbott.

"The dry brush technique of yellow ochre and black on the outside border represents earth textures. I used a cloth to manipulate the paint by rubbing it lightly over the surface. The square cutout in the center of the painting becomes a passageway between the physical and spiritual world. Suspended in the center of the passageway are partial or fragmented kachina images and they are intermediaries or spirit messengers between the two worlds. I used the contour line as a kind of exalted shorthand to get partial images. I transform realism into minimalism and fragment the real to give the viewer just a hint, just a glimpse of reality."

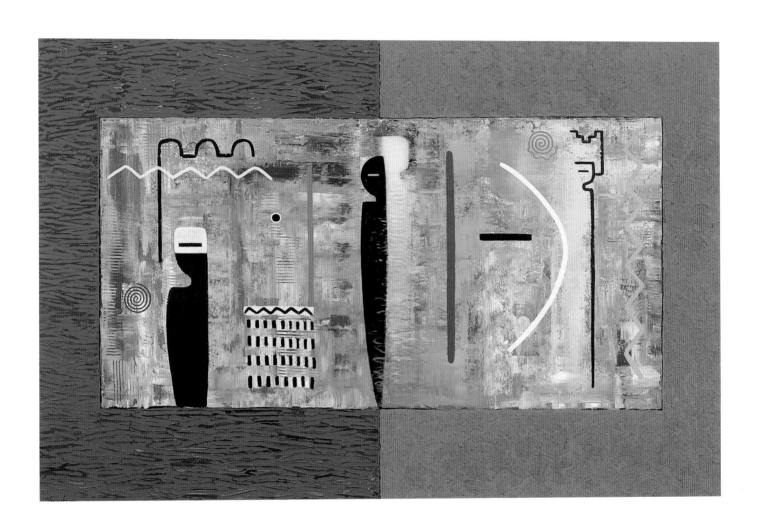

DREAM STATE SERIES. 1994. Acrylic on canvas, 78 x120". Collection Avi and Susie Merav.
The artist first applied thick blue paint to the left outside border of this painting,
then scratched into it to make it resemble the flow and movement of water. On the
right border he applied sand to create the feeling of the land. The center is a motif
he considers of extreme importance in both his paintings and sculpture—the pas-
sageway. In this particular passageway, the blue represents cloud formations. "I
applied fragmented images and pieces of symbols to represent intermediaries—
they are all dreamlike forms. These are fragmentary, 'soft' kachinas. The black and
white line cluster is a storm with lightning above the rain; the beard of a kachina
can be seen here as well. There are two butterfly maidens at the ends, and in the
center are two spirit figures."

SYMBOLISM SERIES I. 1994. Mixed media on canvas, 30 x 20". Collection Fogg Art Museum, Harvard University.

The artist created a collage by bringing together rice and pastel paper and bonding them together with gel. He made the top knot of feathers by working the palette knife very quickly to give it energy. He was trying for a formal stability with a hint of fragmentary, wild movement, and wanted one very spontaneous part of the solid image to put it off balance in just the right manner.

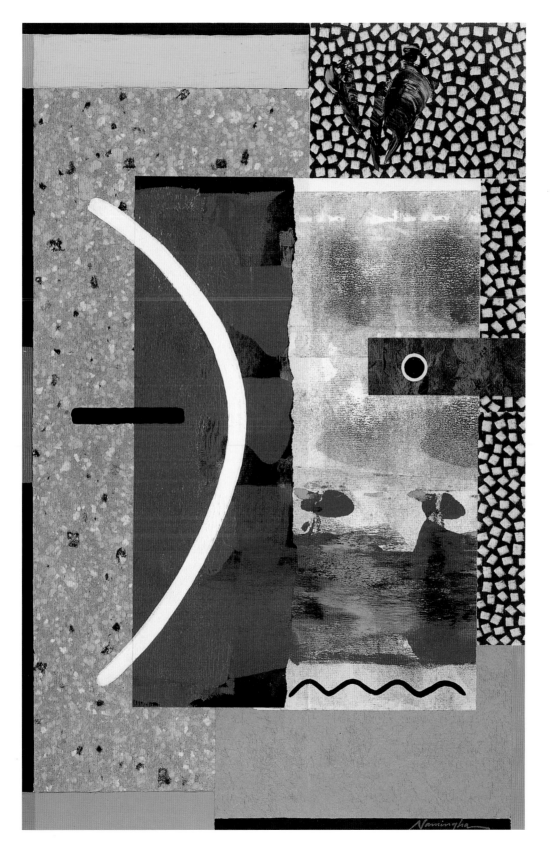

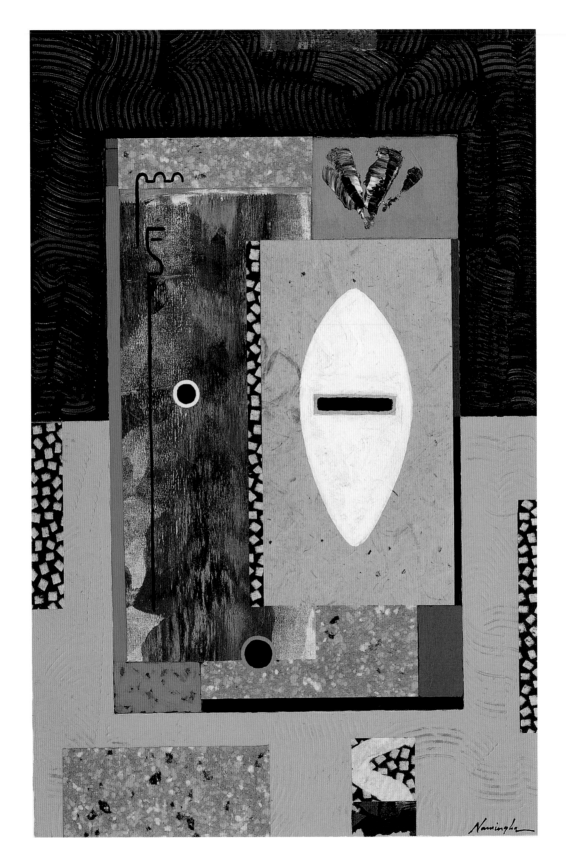

SYMBOLISM SERIES III. 1994. Mixed media on board, 30 x 20". Collection of Wendy and Philip Kistler.

The concept for this painting is the same as the one on page 113. The artist took pains to develop the top and bottom areas, what he calls the "surrounds," not only as contrasting formal elements but to emphasize his feeling of the importance of duality. On the top section his first layer of paint applied to the board was cadmium red mixed with magenta. He subsequently applied thalo blue and mars black. Once the paint had been thickly applied he vigorously dug into it for texture. On the bottom he first applied yellow ochre then white combined with yellow oxide plus a touch of black which produced a deep and luminous light gray. He then worked or "scratched" it. The subject is two overlapping kachinas. On the left one sees a hint of a butterfly maiden. There is abundant collage treatment here in the use of differing kinds of paper. To the artist the series is significant for his stylistic growth. "It set the stage for some of my recent sculpture. After I completed this work I got the idea for some sculpture. Once I started working on those maquettes [models] I got ideas for new paintings. It works both ways."

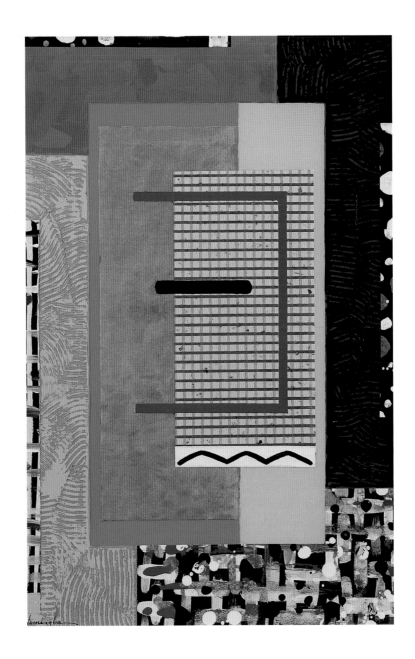

PUEBLO SYMBOLISM I. 1996. Collage on board, 30 x 20". Collection Harold and Elaine Sterling.

"The idea for this painting came when I was working with foam core cutouts to insert into my sculpture maquettes. I used different types of rice paper—the gray crossed lines are rice paper—and then I painted on top to complete the composition. I became fascinated with sheer precision, and I guess you might say I became devoted to the hard, pure edge. I got movement from the splashes and washes on the lower right. I did that because I felt the work was going to be too placid and I had to break away from the stillness."

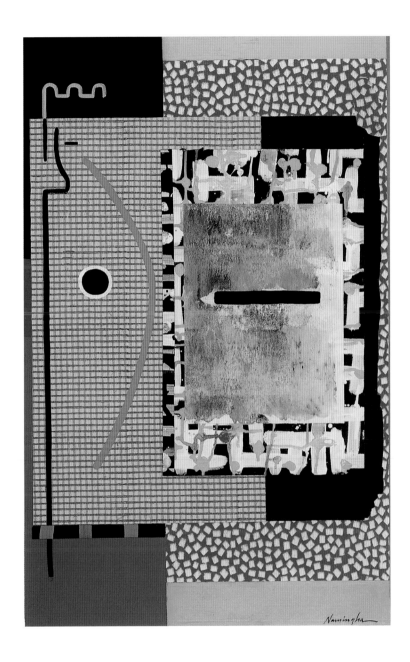

PUEBLO SYMBOLISM II. 1996. Collage on board, 30 x 20". Private collection.

Essentially this is the same concept as the one opposite. The artist explains that the grid on the left is not related in meaning to the kachina. "I just liked the grid lines when I saw them. I'm a big fan of papers that have interesting textures."

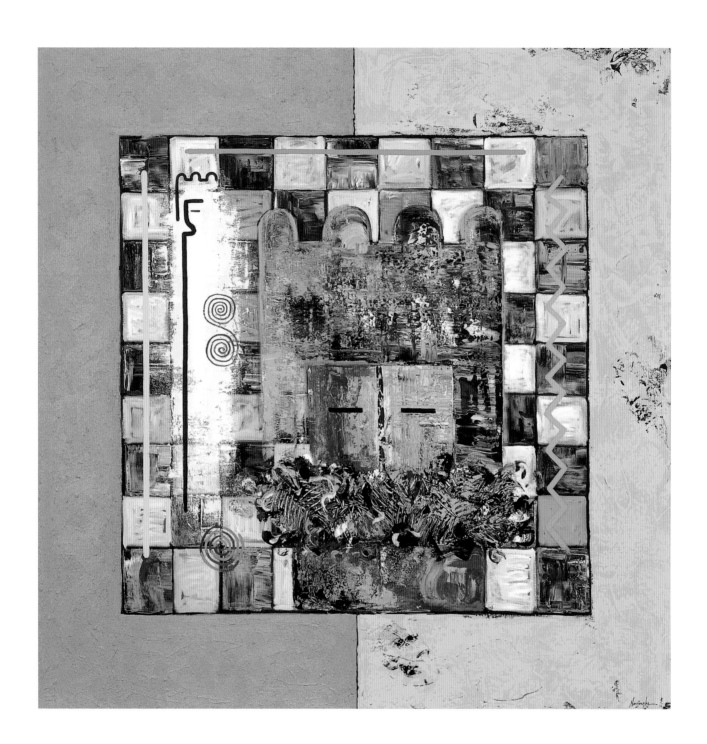

PUEBLO SYMBOLISM. 1995. Acrylic and sand on canvas, 72 x 72". Private collection.

The outside border of the painting, divided by two areas of soft brown applied with a trowel, reflect the two types of sand and the clays used for Hopi pottery. The two colors also symbolize the winter and summer solstices. The center of the painting is intended to be a passageway. The checkered colors represent rain and clouds. The contour line drawing of a Butterfly Maiden appears on the left. Next to her, the double spiral in yellow ochre stands for the migrations of the past and the future. "By this I mean leaving one place and moving to another, establishing yourself in the new environment but still being connected with the old and the past. The past is our future and the future is our past." The large figure in the middle is the Hemis Kachina, representing clouds and rain.

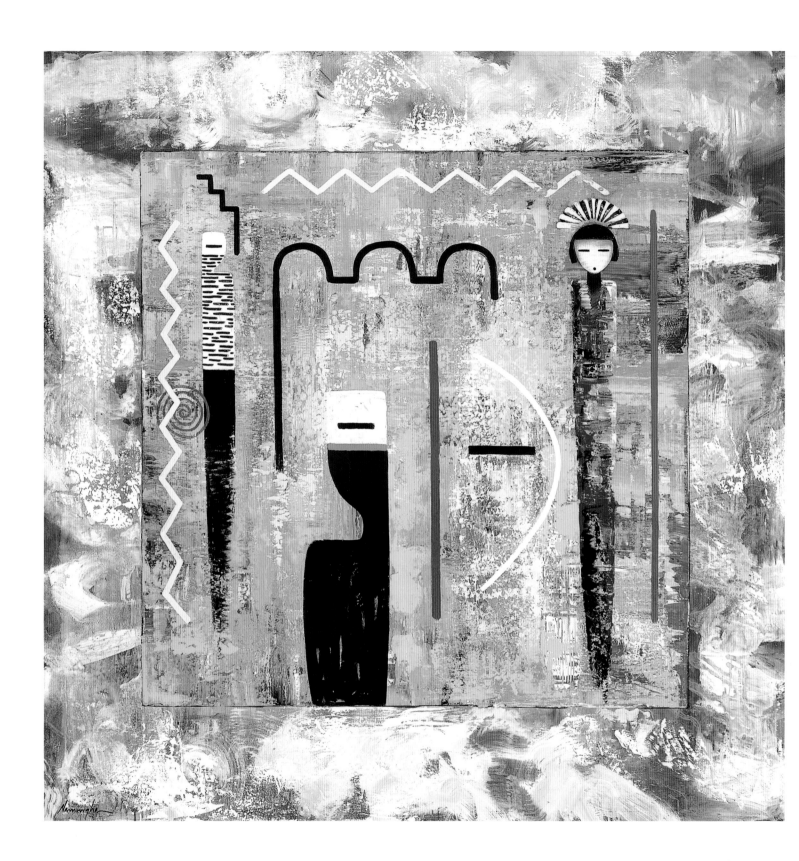

PASSAGE. 1995. Acrylic on canvas, 72x72". Collection Mike and Carol Rose.
The borders are cloud and sunset formations. To achieve the stunning effects, the
artist put his large canvas on the floor and applied various washes of water and
acrylic and let the paint dry in pools. Then he applied color with a dry cloth. "I was
seeking to give the impression of a series of brilliant sunsets coming through clouds
in a sort of perspective that would allow the colors to pass through one another."
Inside the series of sunsets, a square defines a passageway. Here, for contrast, the
color and textures were achieved in a different way. "I applied paint with a trowel
and a floater used for putting plaster on walls and then chopped away with the side
of my hand."

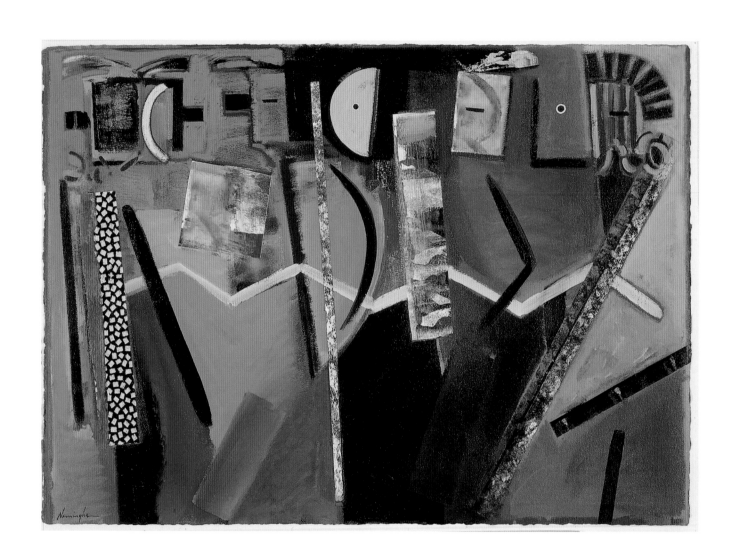

HOPI CEREMONIAL DANCE #2. 1992. Acrylic and collage on paper, 30 x 40".
Bob and Lois Johannigman.
In this painting of seven kachina dancers the artist was trying to evoke stability, something enduringly solid, but with a sense of vivid movement. The images are deliberately partial, fragmented slightly, so that viewers take in only glimpses. "With this composition, I wanted the continuity of ceremonial movement literally to scream out at you."

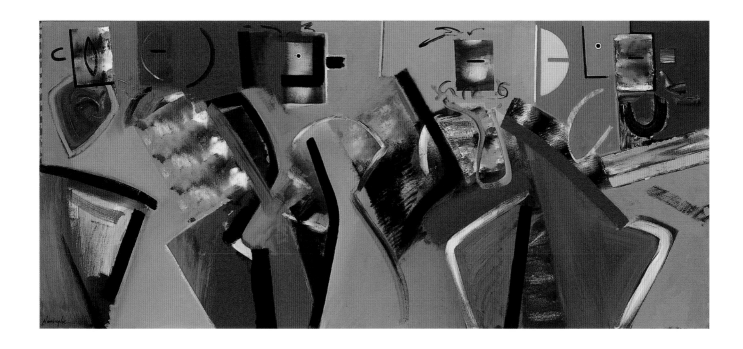

CEREMONIAL DANCE SERIES. 1994. Acrylic on canvas, 37 x 72". Collection Alan
and Julie Halpern.

"Here I have six kachina dancers. I wanted not so much real movement but implied
movement, made by the abstract placement of the arms and legs and bodies. To
me, abstracted movement can suggest more motion than a realistic rendering. In
the dance, different instruments such as the drum, rattle, bells, and turtle shell set
the rhythm. In this painting I want you to hear the clucking of the turtle shells and
the fall of the feet. Different styles of dancing are hinted at in this painting. In one
style, the foot lands directly on the surface and sets a rhythm. In the other the feet
kick into the air accompanied by hand gestures and a special side-to-side move-
ment of the body. Some of the dances can be vigorous, with hand gestures describ-
ing the song; others are slower, with a hypnotic sound to the song. The dancers
may move from side to side or turn in a full circle and then face in the same direc-
tion in unison. I have suggested both dances here."

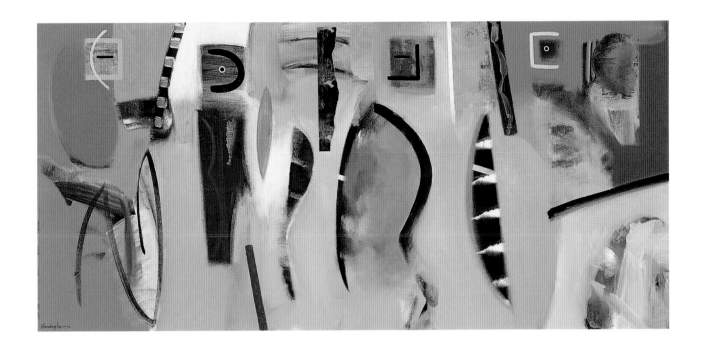

CEREMONIAL DANCE. 1998. Mixed media on canvas, 34 x 72". Private collection.
This version of the ceremonial dance is less literal. The artist has used "simple, slippery forms made by swirls of impressionistic brushstrokes." As he developed the dance series, the paintings became looser and more fluid over time.

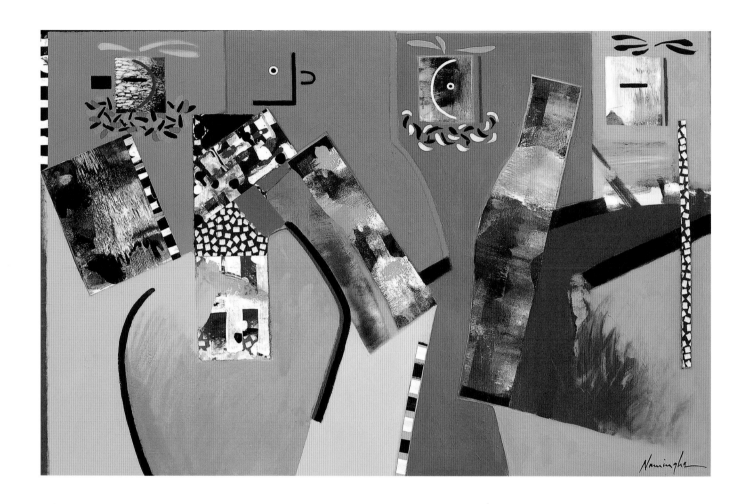

CEREMONIAL DANCE SERIES II. 1996. Acrylic and collage, 26 x40". Collection Archie
and Tina Smith.

In this variation of the dance series there are four dancers. The artist was particu-
larly interested in the subtle differences between the masks. To a large degree this
work is all about textures in motion.

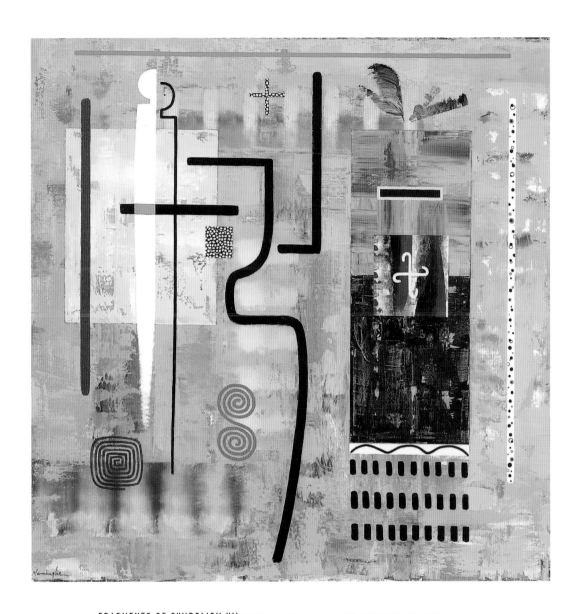

FRAGMENTS OF SYMBOLISM VII. 1996. Acrylic on canvas, 80 x 80'. Collection. Stanley and Johanna Grabias.

This work represents different abstract images of kachinas and symbols found in petroglyphs and pictographs on the walls of mesas and buttes. "This is not a color field painting on which symbols have been applied, but more a color cosmos with symbols imbedded inside. The white streak on the right is a staff with circular forms inside. The white, twisting crosslike motif is a star symbol. The yellow square on the left is an homage to Hans Hoffman because when I was completing this painting, I was reminded of some of his vigorous paintings with blocks and splashes of color. The swastika represents the four cardinal directions. The center, made up of half a kachina face suspended within a cardinal direction symbol, is a sort of passage. The square cluster of round black and white dots represents rain. There are also some double spirals here indicating the complex series of Hopi migrations."

PUEBLO FRAGMENTS. 1996. Acrylic on canvas, 64 x 68". Private collection.

A host of fragmentary kachinas occupies the center. By combining the blue and black at the top and bottom the artist was seeking to represent night and also to create a powerful contrast between the images in the center and the borders. "Blue is for night or late evening. It's a landscape element in a sense, too, and also refers to one of the Hopi cardinal direction colors—blue is west. I like that blue: it reminds me of night."

130



PASSAGE SERIES III. 1994. Mixed media on canvas, 80 x 80". Collection Frances Namingha. The idea of a universal passageway is crucial to the understanding of Namingha's works. As he expresses the concept: "I often try to create landscapes in my mind. In the center is where you see partial images, negative space, and what I call the pas sageway. In Hopi ceremony and, in fact, in any culture's spiritual ceremony, you have some sort of altar or shrine that symbolizes solitude, peace, and connected ness. Each of these stands for a kind of passageway. At our Hopi shrines we lay down corn pollen, corn meal, and prayer feathers and we pray for family longevity, health, bountiful crops, good rains for summer, great harvest in the fall, and for a balanced universe. The passageway I'm referring to is the one that leads from the physical into the spiritual realm and back again. Every culture has that. Many of my new works relate to that essential passageway. Passage pertains to the spiritual as well as the formal aspects of my work."

In this painting the artist covered the borders with a sequence of acrylic washes to represent a pool of water in a sacred spring. In the passageway are suspended fragmented images of kachinas and various symbols that serve as intermediaries between the spirit world and the earthly domain. "Within the passageway I have placed geometric lines and shapes and loose, exploding shapes around the borders. The black vertical slashes on the bottom represent a beard from a kachina mask."

PASSAGE SERIES. 1997. Acrylic on canvas, 72 x 60". Collection Alan and Berte Hirshfield.

The black and white border stands for rain and clouds, a motif found in the head-dress of the Butterfly Maiden kachina, and often tied around the ankle of the Butterfly Maiden dancer. The center is a passageway with fragmented symbols.

Inside the passageway, the blue and gold color combines titanium white, cadmium yellow, and yellow oxide. The turquoise comes from cadmium yellow, white, and thalo blue. On the left side of the passageway, there are mixtures of palette-knife work and brushwork with cadmium red, burnt sienna, cadmium yellow, and Mars black mixed with titanium white. The division of colors reflects the duality within life. The distinctive double spiral with long tail on the right side of the pas-sageway signifies the act of traveling and resettling in a new place but always remembering the original place and continually returning to it.

HOPI MONTAGE #5. 1997. Acrylic on canvas, 72 x 60". Private collection.

The black arches at the top and bottom represent moving clouds. Traditionally, there would only be three half circles, but the artist decided to stretch them across the canvas in formation to give the impression of movement. The midsection of the painting consists of symbols and fragmented Butterfly Maiden kachina images.

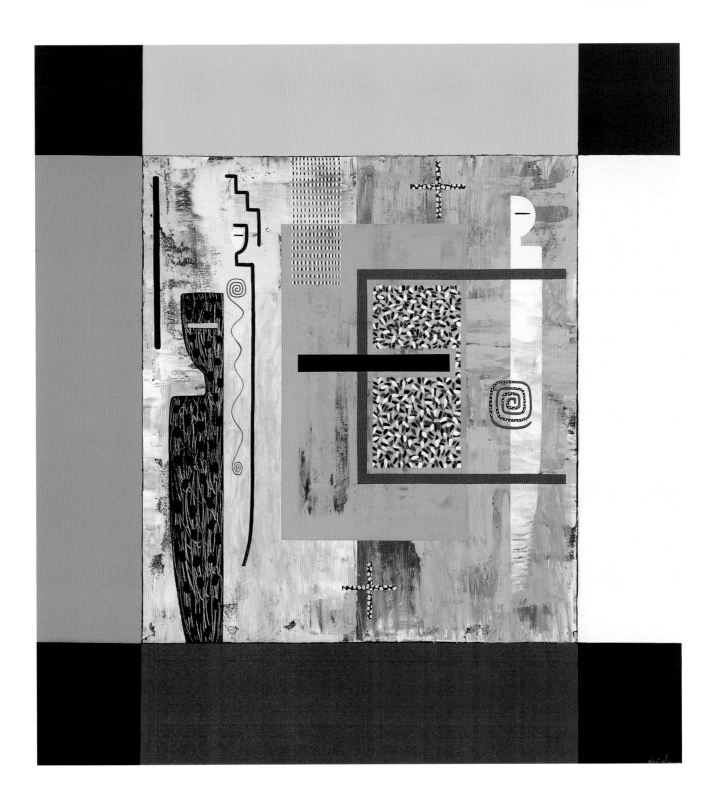

FOUR CARDINAL DIRECTIONS. 1998. Acrylic on canvas, 64 x 60". Collection Frances Namingha.

The four vivid colors applied to the borders of this painting represent the four cardinal directions: yellow for north; red for south; blue for west, and white for the east. "I wanted to block off the corners so that the actual colors would be in the right direction, so I applied black at each corner also for contrast. These colors are also those of the corn the Hopi grow, which includes a blue kernel corn and, of course, yellow, white, and red. Corn meal serves as a vital sustainer of life for the Hopi and is regarded as the king of foods. At Hopi shrines, corn meal and pollen are used as offerings, and the cardinal directions are important both for the location of shrines and for the placement of offerings at those shrines, which are often found far beyond reservation borders."

SCULPTURES

The artist has always created sculpture. What started off as a way of making his paintings and collages three-dimensional has grown into a desire to present realism within a dynamic minimalism and to show flatness merging into roundness and vice-versa.

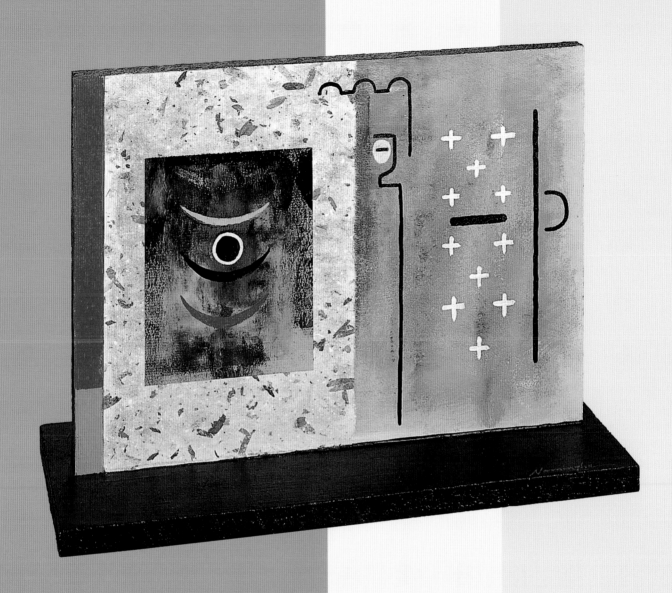

PASSAGE. 1994. Mixed media on board, 10 x 14 x 5.5". Private collection.

"I was curious at first to see how my collages would look if I were to transfer them onto a wood surface. Then I began to wonder what it would look like in a sculptural format. I began experimenting with the idea in this piece. I first painted the surface, then began gluing rice paper and pastel paper on top, and then I created fragmented symbols. To me, this is much more than a painting stuck on a pedestal, because, in a way, the pedestal sanctifies it. I wanted it to be lyrical and capture what I think is the engaging and eternal feel of pastel."

On the left is a partial kachina mask—eye and crescent moons above, and a kachina eye below. The work is painted black on the back.

CLOUD IMAGE I. 1996. Acrylic and collage on wood, 49 x 26 x 24". (Back view). Collection Walter F. and Phyllis Loeb.

The artist was inspired by *Passage*, but here he expanded the concept further. The challenge was to see what he could make of an upright, three-dimensional, elongated flat wooden piece. "I primed the wood first and studied its format, then began painting it. I was thinking of transferring my collages on paper to wood in a fully sculptural manner. I was also interested in preserving the collage feeling and the materials of collage—acrylic, rice paper, and bark. I studied its format from all sides, and then created some preliminary sketches as a reference and began painting the piece. It actually evolved on its own."

The other side of this is shown in the text section.

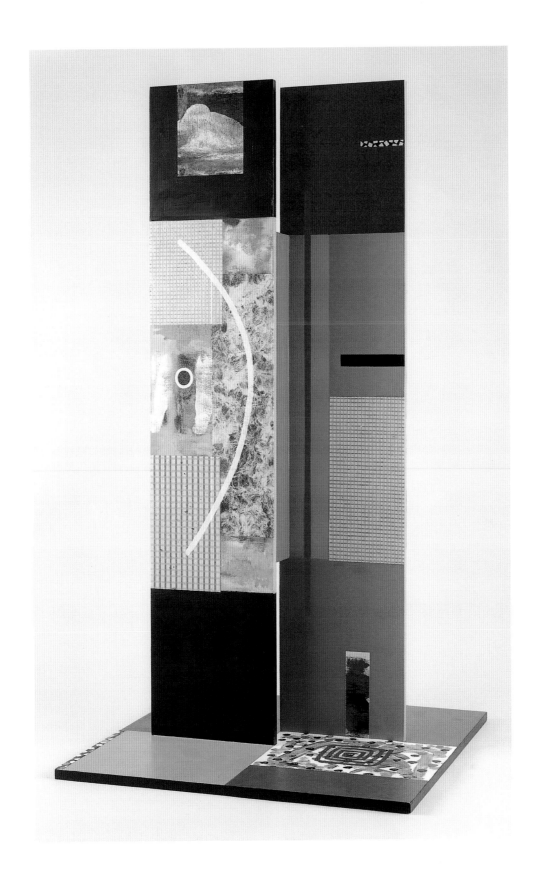

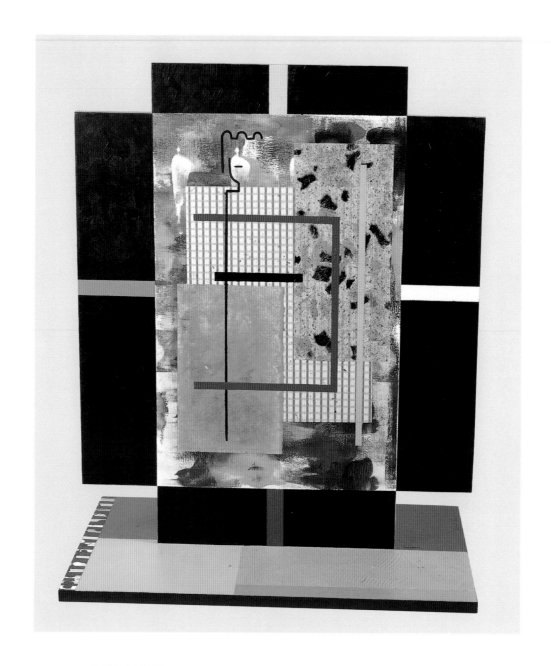

CLOUD IMAGE II. 1996. Mixed media on wood, 32 x 16 x 26". (Front view) Collection
Nadine and Eddie Basha.

This is generally the same idea as *Cloud Image I*, but the format differs. The four
black sides represent the four directions, and the four cardinal colors are painted in
the centers—yellow-north, red-south, blue-west, white-east. These colors also
represent the four colors of corn. The center represents a passageway. "I first
applied under-color washes on the surface, then glued three types of rice paper
overlapping one another. I like the shine of it—it looks almost like glass. The red
contour line is a partial Kachina image and the black horizontal line is the eye."

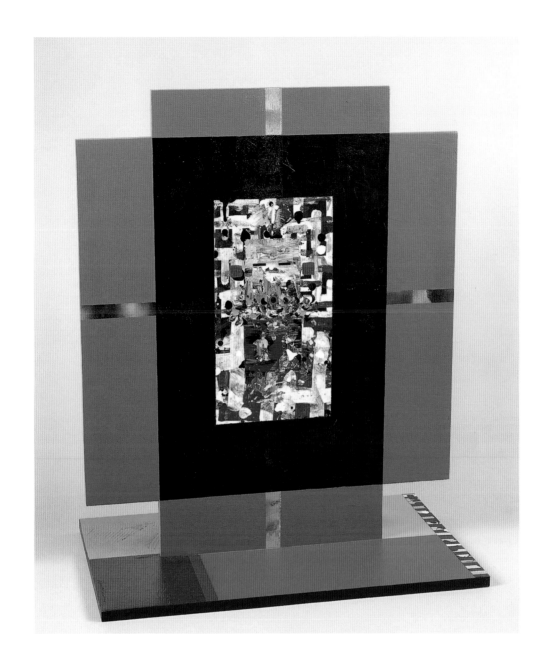

CLOUD IMAGE II. (Back View)

Here, the passageway features a Kachina doll suspended in the center. The surround is painted in black with the cardinal colors all blended together. The pedestal also shows colors symbolizing the cardinal points and the colors of the life-giving corn.

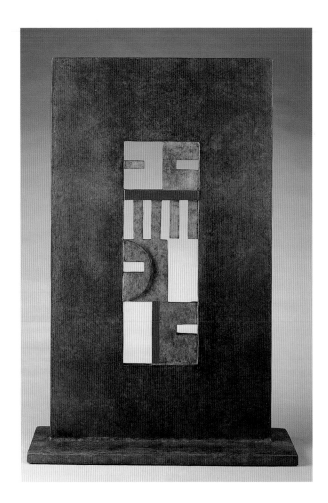

KACHINA SYMBOLISM I. 1994. Bronze, edition of 12, 18 x 12 x 5".

This piece marks an important change of style and concept for the artist, for here he introduced negative spaces into his sculptures for the first time.

"I began with foam core-cutouts, assembled them, and then used the negative space as part of the design element. I saw negative space as a welcome and needed counterbalance to the solid forms. The center forms a passageway, with fragments of kachina faces. From top to bottom, the negative space on the left side reveals the other half of the kachina, with the small horizontal bar indicating an eye. This negative space balances the solid form with a horizontal opening, which is the other eye. Below the face, the vertical lines with negative and positive forms and spaces stands for falling rain. There are two other fragmented kachina images at the bottom."

The artist achieved the desired patina by torching the bronze surface after applying certain chemicals. The colors depend on which chemicals he chooses.

KACHINA SYMBOLISM II. 1996. Bronze, edition of 4, 97.25 x 19.25 x 24".

This marks another change in the stylistic development of the artist's sculpture. It culminates his struggle since youth to achieve the goal of capturing realism within minimalism. Here subject matter is secondary, though definitely neither overlooked nor forgotten. Pure form has become the dominant artistic force.

"At first I had all three panels facing the same direction, but it wasn't working. Looked too static. I started moving the panels in different directions, which gave the piece a greater formal power and interest."

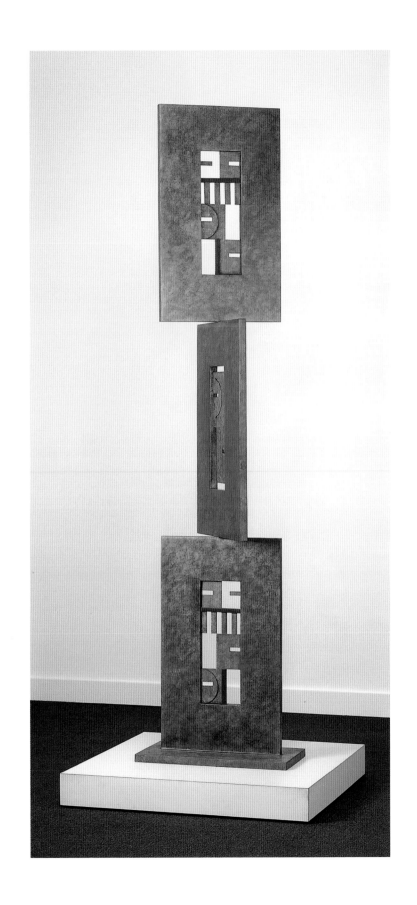

VERTICAL PASSAGE. 1997. Bronze, edition of 6, 97.5 x 20 x 30".

The subject is a kachina and a passageway but the narrative elements are relegated to the background. "I wanted to emphasize the hard-edged sculptural shapes and the interplay of curves within curves. Working with the maquette [model] enables me to move shapes around so that they balance from top to bottom within a vertical void and interact with the negative space within that framed void."

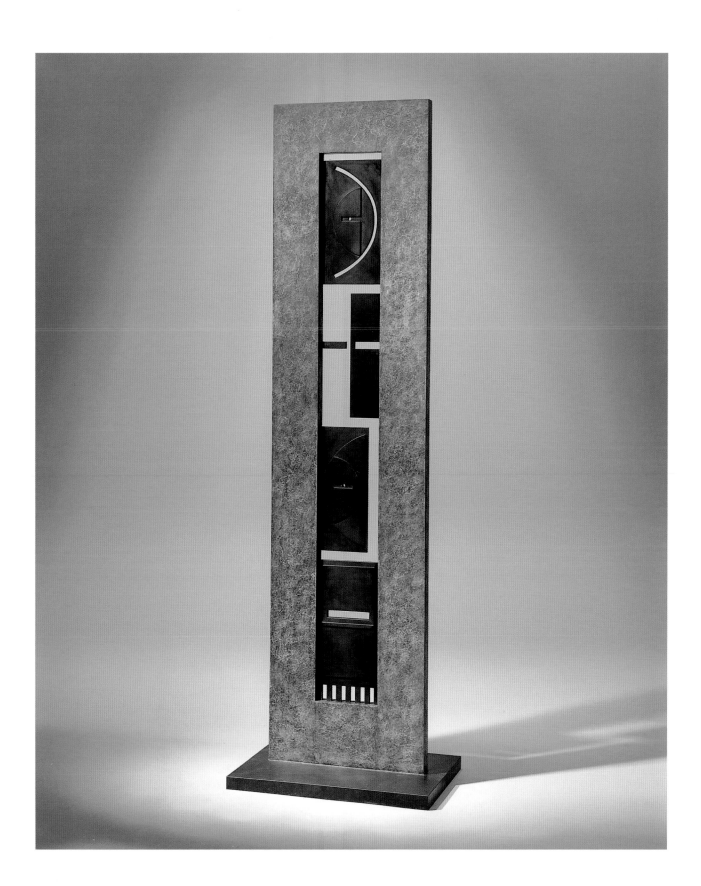

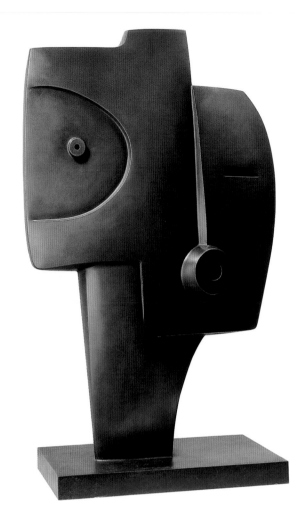

SYMBOLISM I. 1997. Bronze, edition of 6, 51 x 31 x 17.25".

Here the partial kachina images are combined and overlapped. With this piece, the artist took another step away from painting and at the same time looked back to his work of the 1970s. "As I progress, I always look back; in this instance to twenty-eight years before. I take elements I favor from every period of my work and incorporate them into something different—totally at random."

KACHINA SYMBOLISM IV. 1997. Bronze, edition of 6, 50 x 48 x16".

Here the simple abstracted and completely minimal shapes preserve a spirit of high realism. Being less explicit, the forms are more powerful. The goal of the artist has always been to achieve a pure expression, in which the subject matter is implied rather than spelled out. In this work the negative spaces and the perfect placement of forms have become almost musical.

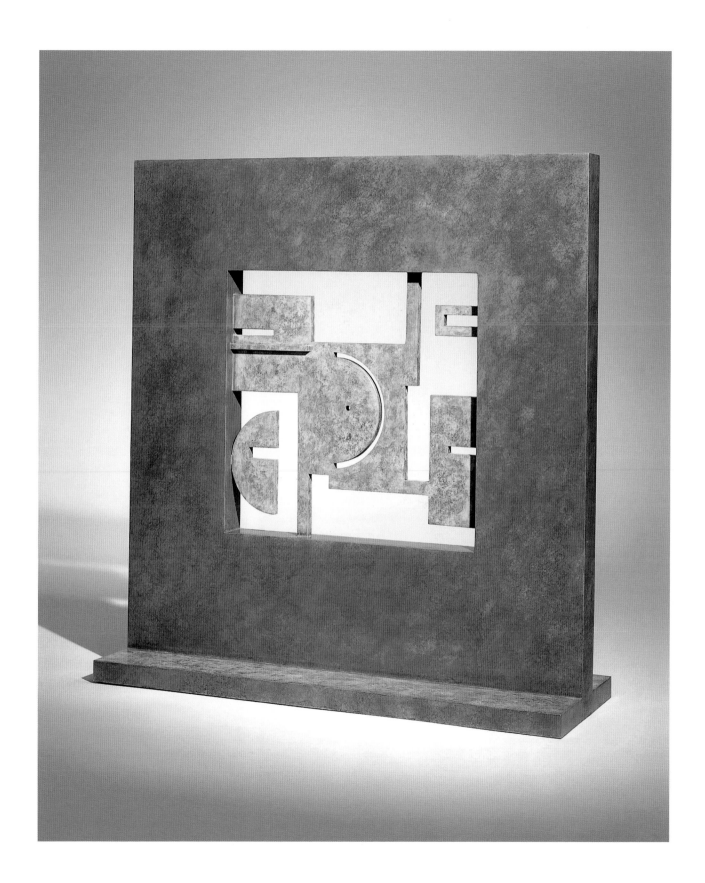

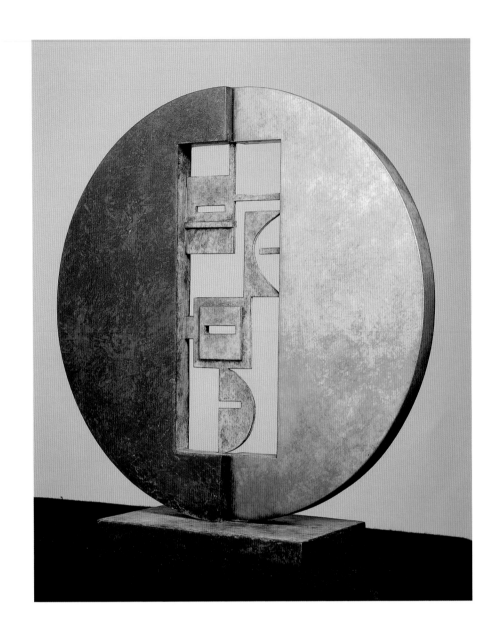

PASSAGE. 1998. Bronze, edition of 2, 8' diameter, 28 x 50".
Collection New Mexico State Capital, Santa Fe, New Mexico.
The grand and subtle forms evoke duality: the colors refer to land textures, the con-
cept of passage, and reminiscences of rituals. But, above all, the work simply and
purely offers a series of shapes and the interplay of negative and positive spaces
holding together in perfect harmony.

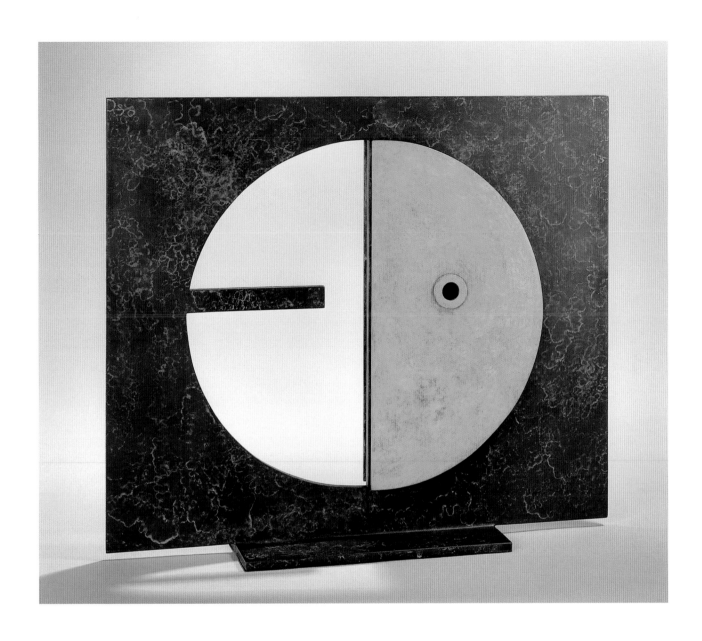

SUN AND MOON I. 1998. Bronze, edition of 6, 24.5 x 29 x 7".

"This is my interpretation of the sun and the moon. Those heavenly bodies reflect opposites, or duality. With the sun, I wanted to minimalize imagery while using negative space and solid forms. At the same time I was trying to achieve a powerful sculptural statement."

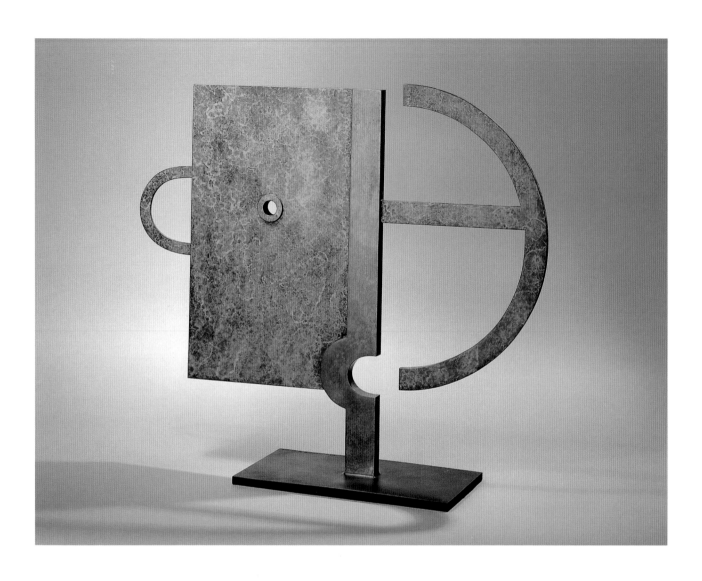

MONTAGE I. 1998. Bronze, edition of 8, 24.5 x 28 x 7.5".
The sculpture assimilates various fragments of kachina images, and for the first
time there are no borders. The artist's objective was to combine free form with min-
imalism, yet maintain the power of a specific image.

FRAGMENTS. 1998. Bronze, edition of 12, 7.75 x 28 x 3.5".

"The title basically explains the piece—it is pure sculpture, with both realism and minimal forms coming together. I have always been intrigued by creating a subtle interplay of solids and voids, shades and colors. I have evolved the subject matter into interplays of negative and positive space. This is what I have been doing in various ways all my life as an artist."

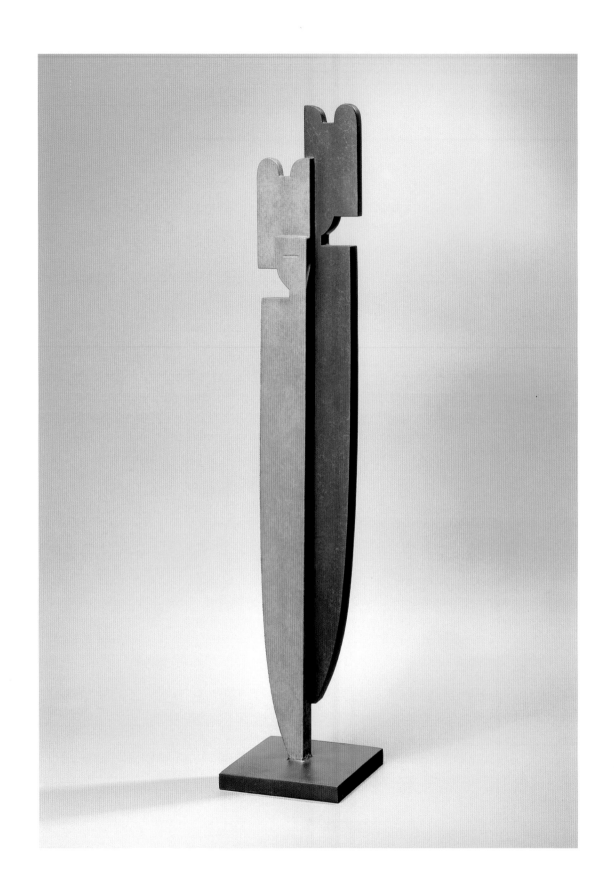

MAIDENS I. 1998. Bronze, edition of 15, 35.5 x 5.5 x 7".
The subject is two Butterfly Maidens distinguished by different patinas.
Here, subject matter gives way to a feeling of pure sculpture.

Exhibitions

ONE-MAN EXHIBITIONS

1973–75 Navajo Gallery, Taos, New Mexico
1973–75 Cassidy Gallery, Albuquerque, New Mexico
1973–86 The Gallery Wall, Phoenix and Scottsdale, Arizona and Santa Fe, New Mexico
1977 "Dan Namingha," Museum of Northern Arizona, Flagstaff, Arizona
1977 "Dan Namingha," Orange Coast College, Costa Mesa, California
1978 "Namingha, Imagery of a Hopi Indian," Sonoma County Library, Santa Rosa, California
1978–79 "Extensions of the Nampeyo Creative Spirit," California Academy of Sciences, San Francisco, California
1980 Dan Namingha Retrospective, The Arizona Bank Galleria, Phoenix, Arizona
1987 "Tewa-Hopi Reflections," Heard Museum, Phoenix, Arizona
1988 Images of the Southwest," National Academy of Sciences, Washington, D.C.
1988 Gerald Peters Gallery, Dallas, Texas
1989 Governor's Gallery, State Capitol, Santa Fe, New Mexico
1989 Gerald Peters Gallery, Santa Fe, New Mexico
1990 Niman Fine Art, Santa Fe, New Mexico
1991 "Timeless Land and Enduring Images," Palm Springs Desert Museum, Palm Springs, California
1992 "Extending Pueblo Imagery," Nevada State Museum, Las Vegas, Nevada
1992 "Dan Namingha," University of Hartford, Hartford, Connecticut
1992 The Art Guild, Farmington, Connecticut
1992 Susan Duval Gallery, Aspen, Colorado
1993 Niman Fine Art, Santa Fe, New Mexico
1994 "Dreamscapes," Susan Duval Gallery, Aspen, Colorado

1995 "Fragments of Symbolism and Landscapes," The Fogg Art Museum, Cambridge, Massachusetts
1996 Bentley Gallery, Scottsdale, Arizona
1996 "Metaphors of Culture and Place," Museum of Fine Arts, Santa Fe, New Mexico
1996 Niman Fine Art, Santa Fe, New Mexico
1997 "Passages," Susan Duval Gallery, Aspen, Colorado
1997 Joy Tash Gallery, Scottsdale, Arizona
1997 "Structural Dualities," Wheelwright Museum, Santa Fe, New Mexico
1998 J. Cacciola Gallery, New York City
1998 Joy Tash Gallery, Scottsdale, Arizona
1998 J. Cacciola Gallery, New York City
1998 "Transitions and Time," Montclair Art Museum, Montclair, New Jersey
1999 Niman Fine Art, Santa Fe, New Mexico
2000 Vanier Gallery, Scottsdale, Arizona
2000 "Reflections on the Natural Way," Reading Public Museum, Reading, Pennsylvania
2001 Carnegie Mellon University, College of Fine Arts, Pittsburgh, Pennsylvania

GROUP EXHIBITIONS

1967 University of Kansas, Drawing and Sculpture Exhibit, Lawrence, Kansas
1968 Heard Museum Indian Arts and Crafts Exhibit, Phoenix, Arizona
1969 Heard Museum Indian Arts and Crafts Exhibit, Phoenix, Arizona
1972 "27th American Indian Artists Exhibition," The Philbrook Art Museum, Tulsa, Oklahoma
1972 Heard Museum Indian Arts and Crafts Exhibit, Phoenix, Arizona
1972 The Jamison Galleries, Santa Fe, New Mexico
1973 Navajo Gallery, Taos, New Mexico
1973 The Cassidy Gallery, Albuquerque, New Mexico
1974 "Nampeyo Family Exhibition," Muckenthaler Cultural Center, Fullerton, California
1975 Heard Museum Indian Arts and Crafts Exhibit, Phoenix, Arizona

1977 "Indian Art Today," Museum of Albuquerque, Albuquerque, New Mexico

1977 "Alumni Exhibition," Institute of American Indian Arts Museum, Santa Fe, New Mexico

1977 "Invitational Sculpture III Exhibition," The Heard Museum, Phoenix, Arizona

1978 "Printmakers Invitational," Museum of Northern Arizona, Flagstaff, Arizona

1978 "Graphics Invitational," New Britain Museum of American Arts, New Britain, Connecticut

1978 Heard Museum, Phoenix, Arizona

1978 "Fiftieth Anniversary Exhibit," Museum of Northern Arizona, Flagstaff, Arizona

1978 "Messengers of the Earth," California State University, Sacramento, California

1979 "The Real People," Sponsored by Native American Center of the Living Arts, Tour of Cuba

1979 "Contemporary Amerindian Painting," Traveling Exhibit: Chile, Bolivia, Peru, Colombia, and Ecuador

1980–81 "Hopi Kachina Spirit of Life," Traveling Exhibit: California Academy of Sciences, San Francisco, California; Carnegie, Museum, Pittsburgh, Pennsylvania; National Museum of American Art, Smithsonian Institute, Washington, D.C.

1980 "Spirit of the Earth," Native American Center for the Living Arts, Niagra Falls, New York

1981 Salon d'Automne, Grand Palais, Paris, France

1982 University of Nebraska, Sheldon Memorial Art Gallery, Lincoln, Nebraska

1982 "Inaugural Art Exhibit," Armand Hammer United World College, Montezuma, New Mexico

1982 Amerindian Circle Smithsonian Institution, Washington, D.C.

1983 "Flagstaff Festival of Native American Arts," Flagstaff, Arizona

1984 FIAC International Exhibit, Grand Palais, Paris, France

1983–86 European Touring Exhibition, "Dan Namingha and Allan Houser," Amerika Haus, Berlin, Germany

The Stare Library and Archives of Lower Saxony, Hanover, Germany
Amerika Haus, Stuttgart, Germany
German American Institute, Heidelberg, Germany
German American Institute, Nuremberg, Germany
Amerika Haus, Munich, Germany
Kunstlerhaus, Gallery of Fine Arts, Vienna, Austria
The Museum of Modern Art, Osijek, Yugoslavia
The Museum of Modern Art, Dubrovnik, Yugoslavia
The Modern Gallery, Rijeka, Yugoslavia
The Naprsktkova Museum, Prague, Czechoslovakia
The Museum of Tarii, Crisurilor, Oredea, Romania
The Museum of Art, Craiova, Romania
The Museum of Art of the Republic of Romania, Bucharest, Romania
The National Museum, Sofia, Bulgaria
The Gallery of East Slovakia, Kosice, Czechoslovakia

1986 "Contemporary Visions of New Mexico," Sangre de Cristo Art and Conference Center, Pueblo, Colorado

1987 "NASA Art Program," Kennedy Space Center, Cape Canaveral, Florida

1988 "Visions of Flight," NASA Art Collection, Traveling Exhibit: Kennedy Space Center, Cape Canaveral, Florida; Mesa, Arizona; Huntsville, Alabama; Washington, D.C.

1988 National Cowboy Hall of Fame and Western Heritage Center, Oklahoma City, Oklahoma

1989 "Glyphs of New Mexico, New Interpretations," Governor's Gallery, Santa Fe, New Mexico

1989 "Sights and Sounds," Kennedy Space Center Art Gallery, Cape Canaveral, Florida

1993 "TOI TE AO Exhibition," Te Taumata Art Gallery, Auckland, New Zealand

1993–94 "The Artist as Native, Reinventing Regionalism," Traveling Exhibit: Maryland

Institute and College of Art, Baltimore, Maryland; Westmoreland Museum of Art, Greensburg, Pennsylvania; Owensboro Museum of Fine Art, Owensboro, Kentucky; Albany Institute of History and Art, Albany, New York; Babcock Galleries, New York City; Middlebury College Museum of Art, Middlebury, Vermont

1994 "This Path We Travel," National Museum of the American Indian, New York City

1995 Colorado Springs Fine Arts Center, Colorado Springs, Colorado

1995 "Enduring Inspirations, New Mexico Landscape Painting," Cline Gallery, Santa Fe, New Mexico

1995 "Art and the U.N., One World Many Visions," New Canaan, Connecticut

1996 "Covering The West," Traveling Exhibit: Tucson Museum of Art, Tucson, Arizona; National Cowboy Hall of Fame and Western Heritage Center, Oklahoma City, Oklahoma; Autry Museum of Western Heritage, Los Angeles, California; Albuquerque Museum, Albuquerque, New Mexico

1996 "Dan Namingha, Allan Houser, Niman Fine Art, Santa Fe, New Mexico

1997 "Dan Namingha, Allan Houser," Fritz Scholder," Niman Fine Art, Santa Fe, New Mexico

1998 "MINIATURES 98," Albuquerque Museum, Albuquerque, New Mexico

1999 Vanier Gallery, Scottsdale, Arizona

1999 J. Cacciola Gallery, New York City

COMMISSIONS

1980 *View From Walpi,* 27 foot mural, Sky Harbor Airport, Phoenix, Arizona

1985 *Emergence,* painting, for NASA, Washington, DC

1989 *Star Kachina Spirit and Orbiter,* painting for NASA, Kennedy Space Center, Cape Canaveral, Florida

1995 "Distinguished Artist of the Year Award," bronze sculpture, Santa Fe Rotary Foundation, Santa Fe, New Mexico

1996 *Hopi Eagle Dance Series,* Lithograph commemorating the 150th anniversary of the founding of the Smithsonian Institution, Washington, D.C.

1996 *Madama Butterfly,* lithograph commemorating the 40th Season of the Santa Fe Opera, Santa Fe, New Mexico

1996 "Visionary Award," bronze sculpture, Institute of American Indian Arts, Santa Fe, New Mexico

1998 *New Mexico Dusk #2,* painting, Santa Fe Chamber Music 27th season, Santa Fe, New Mexico

1999 Selected by The International Museum of 20th Century Arts & Cultural Centre (TIMOTCA) to create a painting *Passage XI,* for the permanent collection, representing Native American Culture. Art Beyond Borders in cooperation with UNESCO at the United Nations, New York City.

1999 *Eagle,* a monumental bronze sculpture, Finova Group Inc., Scottsdale, Arizona

1999 Commissioned to create a bronze sculpture as the Cinema Santa Fe Film Festival Award

1999 *Passage,* a monumental bronze sculpture for the New Mexico State Capitol, Santa Fe, New Mexico

Collections

Albuquerque Museum, Albuquerque, New Mexico

Arizona Bank Collection, Phoenix Arizona

British Royal Collection, Princess Anne, London, England

City of Phoenix Collection, Sky Harbor International
 Airport, Phoenix, Arizona

City of Scottsdale Fine Arts Collection, Scottsdale,
 Arizona

Dahlem Museum, Berlin, Germany

Eiteljorg Museum of American Indian and Western Art,
 Indianapolis, Indiana

Finova Group Inc., Scottsdale, Arizona

Fogg Art Museum, Harvard University, Cambridge,
 Massachusetts

Gallery of East Slovakia, Kosice, Czechoslovakia

Hallmark Collections and Archives, Kansas City, Missouri

Heard Museum, Phoenix, Arizona

Institute of American Indian Arts, Santa Fe, New Mexico

Intrawest Financial Corporation, Denver, Colorado

Millicent Rogers Museum, Taos, New Mexico

Montclair Art Museum, Montclair, New Jersey

Mountain Bell Collection, Albuquerque, New Mexico

Museum of Fine Arts, Santa Fe, New Mexico

Museum of Northern Arizona, Flagstaff, Arizona

Naprstkovo Museum, Prague, Czechoslovakia

NASA Art Collection, Washington, D.C., Kennedy Space
 Center, Cape Canaveral, Florida

Native American Center for the Living Arts, Niagara
 Falls, New York

New Mexico State Capitol, Santa Fe, New Mexico

Opto 22 Corporation, Huntington Beach, California

Palm Springs Desert Museum, Palm Springs, California

Smithsonian Institution, Washington, D.C.

Sundance Institute, Provo, Utah

U.S. Department of Interior, Indian Arts Collection,
 Washington, DC

United States Embassy, Brasilia, Brazil

United States Embassy, Caracas, Venezuela

Wheelwright Museum, Santa Fe, New Mexico

Awards and Honors

Receives Art Scholarship to the University of Kansas,
 Lawrence, Kansas, 1967

Special Category Award, 27th American Indian Artist
 Exhibition, Philbrook Art Museum, Tulsa, Oklahoma,
 1972

Invited Guest Artist, NASA, Cape Canaveral, Florida, to
 witness the 51-G *Discovery* Shuttle lift-off, 1985

Invited Guest Artist, "Return to Flight" NASA, Edward's
 Air Force Base, California, to witness the landing of
 STS-26 *Discovery* Shuttle, 1988

Guest artist, Workshop and Symposium with Maori
 Contemporary Artists, Wellington, New Zealand, 1991

Invited Guest Lecturer, University of Hartford, Hartford,
 Connecticut; Central Connecticut State University,
 New Britain, Connecticut; St. Joseph's College, West
 Hartford, Connecticut, 1992

Guest artist and judge, "Zimbabwe Heritage:
 Contemporary Visual Arts," exhibition, National
 Gallery of Zimbabwe, Harare, Africa 1993

Award and tribute from The Harvard Foundation, Fogg
 Art Museum, Harvard University, Cambridge,
 Massachusetts, 1994

"New Mexico Governor's Award" for Excellence and
 Achievement in the Arts, Santa Fe, New Mexico, 1995

"Distinguished Artist of the Year Award," Rotary
 Foundation, Santa Fe, New Mexico, 1995

"The Visionary Award," The Institute of American Indian
 Arts, Santa Fe, New Mexico, 1997

"Those Who Make A Difference," The Institute of the
 Preservation of the Original Languages of the
 Americas, Santa Fe, New Mexico, 1998

Chronology

1950 Born May 1, to Dextra Namingha, Hopi reservation, Keams Canyon, Arizona.

1956 Begins elementary school at Polacca Day School, Hopi reservation.

1957 Second-grade teacher, Lillian Russell, converts old sandstone building into studio space for young Hopi and Tewa students, and teaches painting and drawing.

1960 Dextra Namingha marries Edwin Quotskuyva from the village of Kykostmovi.

1961 Begins junior high school at Keams Canyon Boarding School. Studies art with Ted Parkhurst.

1964 Begins Mingus High School, Jerome, Arizona. Studies art with Mel Minthorn.

1966 Enrolls in Ganado Boarding School as a sophmore. Studies art with Mrs. Kirby.

1967 June and July: Attends University of Kansas on summer art scholarship. Studies with Judd Scott, Philip Van Voorst, and Barbara Wille. Namingha's work is selected and included in the Drawing and Sculpture Exhibit at the University.
August: Enrolls in the Institute of American Indian Arts (I.A.I.A.) in Santa Fe, New Mexico. Studies advanced painting with Otellie Loloma. Studies architectural drawing, photography, commercial art and two-and three-dimensional art with Kay Weist.

1969 May: Graduates from the Institute of American Indian Arts.
August and September: Attends The American Academy of Art in Chicago.
Studies briefly at the Academy, spends time visiting and studying contemporary exhibits at Chicago Art Institute.
October: Leaves Academy to enlist in the United States Marine Corps. Spends time stationed at Kaneohe Marine Air Base in Hawaii. He is assigned to the Pacific Fleet Marine Force, Okinawa, training in counterguerilla warfare, and at Mount Fuji, Japan, for cold weather missions.

1972 January: Returns to the United States, receives honorable discharge from the military.
February: Returns to Santa Fe, New Mexico. Visits former Instructor, Otellie Loloma, and Lloyd Kiva New, dean of I.A.I.A. Studio is provided for him as a postgraduate taking an art history course. Begins first period of intense painting, through spring semester.
May: Meets Frances Garcia. Submits a painting in the professional category to the Philbrook Art Museum in Tulsa, Oklahoma. Is presented with a special category award.
School term ends at I.A.I.A. Works part-time at Shidoni Bronze Foundry, Tesuque, New Mexico and continues to paint.
September 29: Marries Frances Garcia at San Juan Pueblo, New Mexico. He receives his first gallery representation, by Jamison Galleries, Santa Fe, New Mexico.

1973 March 4: Birth of son Arlo Namingha.
July: First solo exhibit, Navajo Gallery, Taos, New Mexico.

1974 First bronze sculpture cast at Shidoni Foundry, Tesuque, New Mexico. Creates first lithograph, Tamarind Institute, Albuquerque, New Mexico.

1976 Exclusive representation agreement, The Gallery Wall, Phoenix, Arizona.

1977 First solo museum exhibition, Museum of Northern Arizona, Flagstaff, Arizona.
Solo Exhibit at Orange Coast College, Costa Mesa, California.
October 23: Birth of son, Michael Namingha.

1978 Shows sculpture at Invitational Sculpture III exhibition, The Heard Museum, Phoenix, Arizona.
Exhibits at Graphics Invitational, New Britain Museum of American Art, New Britain, Connecticut.

1979 Travels to San Francisco for opening of solo exhibit at California Academy of Sciences. Creates first monotypes at Naravisa Press, Albuquerque, New Mexico.

1980 Commissioned to paint a 27-foot mural, "View from Walpi," for Sky Harbor Airport, Phoenix, Arizona.

1981 Travels to Europe to participate in exhibition at the Salon d'Automne, le Grand Palais, Paris, France.

1983 Returns to Europe to inaugurate opening of European touring exhibition at Amerika Haus, Berlin. Lectures while in Germany.

1984 Attends opening of European touring exhibit at Kunstlerhaus, Gallery of Fine Art, Vienna, Austria.
PBS films a documentary: "Dan Namingha, American Indian Artist II."

1985 PBS film is aired nationally.
Invited by National Aeronautics and Space Administration (NASA) to witness *Discovery* Shuttle liftoff at Cape Canaveral, Florida. Commissioned to create a painting, "Emergence," for NASA Art Collection.

1986 Expiration of agreement for exclusive representation by The Gallery Wall.

1987 Solo Exhibition, "Tewa-Hopi Reflections," at The Heard Museum, Phoenix, Arizona.

1988 Solo Exhibition, National Academy of Sciences, Washington, D.C.
Interviewed by Charlie Rose on "CBS Nightwatch."

1989 Invited by NASA to witness shuttle landing at Edwards Air Force Base in California. Commissioned to create additional paintings for the NASA Art Collection.
"The Art of Dan Namingha" filmed for "CBS Sunday Morning," interview by Robert Pierpoint. Solo exhibit, Governor's Gallery, New Mexico State Capitol, Santa Fe.

1990 May: Niman Fine Art Opens on Lincoln Avenue in Santa Fe.

1991 Solo exhibit, "Timeless Land and Enduring Images," Palm Springs Desert Museum, California.

1992 Guest Artist, workshop and symposium with contemporary Maori artists, travels to Wellington, New Zealand.
Solo exhibit, "Dan Namingha: Extending Pueblo Imagery," Nevada State Museum, Las Vegas. Guest lecturer: University of Hartford, Hartford, Connecticut; Central Connecticut State University, New Britain Connecticut; St. Joseph's College, West Hartford, Connecticut. PBS films television documentary, "Dan Namingha: Seeking Center." Film receives regional Emmy Award.

Travels to Canada and Hawaii, collaborates with fifteen other artists to create outdoor installations with natural materials. Sponsored by the Smithsonian Institution.

1993 Guest artist and judge, "Zimbabwe Heritage: Contemporary Visual Arts" exhibition, National Gallery of Zimbabwe, Harare.

1994 Solo exhibition: "Fragments of Symbolism and Landscapes," Fogg Art Museum, Cambridge, Massachusetts. Receives Harvard Foundation Award, Harvard University.
Attends opening of "This Path We Travel," collaborative exhibit with fifteen other artists, National Museum of American Indian, New York.

1995 Receives "Distinguished Artist of the Year" award, Rotary Foundation, Santa Fe, New Mexico
Receives Governor's Award for Excellence and Achievement in the Arts, State of New Mexico.

1996 Creates lithograph, *Madama Butterfly* for Santa Fe Opera, commemorating the Opera company's 40th season.
August-December: Solo exhibition, "Metaphors of Culture and Place," Museum of Fine Arts, Santa Fe, New Mexico.
Creates lithograph *Hopi Eagle Dance Series*, Commemorating the 150th anniversary of the Smithsonian Institution, Washington, D.C.

1997 May: Solo sculpture and painting exhibition, "Structural Dualities," Wheelwright Museum, Santa Fe, New Mexico.

1998 Solo exhibition, "Transitions and Time," Montclair Art Museum, Montclair, New Jersey.

1999 Commissioned by the Santa Fe Chamber Music to create a painting commemorating its 27th season.

1999 Commissioned by New Mexico State Capitol Art Foundation to create a monumental outdoor sculpture for the State Capitol.

2000 September: Solo exhibition, "Art of Dan Namingha," Reflections on the Natural Way," Reading Public Museum, Reading, Pennsylvania.

Photograph credits: Lynn Lown
Herbert Lotz, Eric Swanson, Suzanne Deats